NEW YORK
CHARACTERS

NEW YORK CHARACTERS

GILLIAN ZOE SEGAL

FOREWORD BY
GEORGE PLIMPTON

W · W · NORTON & COMPANY
NEW YORK · LONDON

For information about permission to reproduce selections from
this book, write to Permissions, W.W. Norton & Company, Inc.,
500 Fifth Avenue, New York, NY 10110.

Design by Gillian Zoe Segal and Rubina Yeh
The text of this book is composed in Perpetua
with the display set in Perpetua
Manufacturing by Mondadori Printing, Verona

Library of Congress Cataloging-in-Publication Data
Segal, Gillian Zoe.
New York characters / Gillian Zoe Segal.
p. cm.
ISBN 0-393-04196-4
1. New York (N.Y.)—Biography—Pictorial works. 2. Eccentrics and
eccentricities—New York (State)—New York—Biography—Pictorial works. 3.
Celebrities—New York (State)—New York—Biography—Pictorial works. 4. New York
(N.Y.)—Biography. 5. Eccentrics and eccentricities—New York (State)—New
York—Biography. 6. Celebrities—New York (State)—New York—Biography. I. Title.
F128.56 .S44 2001
920.0747'1—dc21 2001026608

W.W. Norton & Company, Inc.
500 Fifth Avenue, New York, N.Y. 10110

W.W. Norton & Company Ltd.
Castle House, 75/76 Wells Street, London W1T 3QT

2 3 4 5 6 7 8 9 0

To Leanor,
who gave me life and has continued to do so at every turn.

To Peter,
for his constant encouragement, patience, love, and support.

CONTENTS

FOREWORD

I'm not sure I'm the one to introduce this collection, especially since I am one of the people Gillian Zoe Segal saw fit to photograph. I have forgotten the circumstances of how that happened, but it seems legitimate since I am seated comfortably enough—no sign of objection—in my own apartment.

Nor am I quite sure why she has characterized me as a "New York Character"—jowl to jowl, so to speak, with the likes of David Blaine, who not long ago enclosed himself in a huge block of ice and put himself on display in Times Square, or Jennifer Miller (a noted bearded lady), or Dick Zigun, who runs a Coney Island freak show, or Larry Goodman, better known as "Dancin' Larry," who performs a gyration of sorts in the aisles of Madison Square Garden during the Ranger games, or indeed Ken Krisses, the president of the Polar Bear Club whose members follow him into the frigid Atlantic in midwinter.

The question arises, have I been included in this gallery of eccentrics because I am indeed one myself? Fortunately, there are enough portraits of relatively non-oddball types (at least to my mind)—Ed Koch, Yogi Berra, John McEnroe, Kitty Hart, among them—to give me hope that I am in the "relatively normal" classification. But then again, Gillian has aimed her camera at people who interest her no matter what they do, and since the portraits are very good—that is, they linger in the mind once the book is closed—all of us should be proud we are included.

With the exception of a couple of "action" shots (Dancin' Larry at work in the Garden and a man named Julio Diaz who is dancing in the subway with a plastic doll named Lupita), the contents of *New York Characters* are portraits, taken of those who obviously don't worry about which is the "better" side of their features and accordingly don't jockey themselves into position to have this established. Indeed, I doubt many in this wonderfully eclectic selection have ever faced a portraitist before. Fortunately, Gillian has the ability to put her subjects at ease. It is the mark of a good photographer to catch something of the subject's inner nature, the glint of character that the best of painters strive to reflect in their work, and this, it seems to me, Gillian has done triumphantly.

GEORGE PLIMPTON
NEW YORK CITY 2001

Acknowledgments

So many people have been generous with their help in the completion of this book. I would like to thank: Those who gave me references and/or helped me make contacts: Letty Aronson, Jeff Blau, Rebecca Carver, Lisa Chajet, Steve Clark, Leslie Cohan, Sharon Dizenhuz, Meredith Elson, Ian Gerard, Brian Gordon, Geoff Grant, Gordon Greenberg, Joe Guiliano, Marni Gutkin, Rob Horowitz, Dave Kaplan, Corey Kilgannon, David Leinheardt, Billy Macklowe, Peter Martino, Wendy Masters, Jesse McKinley, Tod Mercy, Peter Minikes, Joanna and Moses Port, Lisa Rance, Jenny Reinhardt, Leah Reisman, Jonathan Marc Sherman, Matt Sirovich, Edward Skyler, Robert Speyer, Jessica Queller, and Tod Waterman. A special thanks to Andrew Blum, David Friedland, Ethan Youngerman, and Jonathan Weisgal. My family, Alvin, Andrew, Jennie, Justin, Raquel, Bubby, Zach, and the Lattmans, for their endless love and support. Pam Bernstein, Phil Block, Adam Eidelberg, Terry De Roy Gruber, Arthur Klebanoff, and Harvey Stein, for some much needed professional guidance. All my characters, for agreeing to be a part of this and donating their time, especially Hoop, Curtis Sliwa, Zoe Koplowitz, Henry Hope Reed, and Dr. Z, for giving me some terrific suggestions, and George Plimpton, for his kind words in the foreword to this book. Rubina Yeh, for her help designing this book. And I am especially grateful to Jim Mairs, my editor at Norton, for being open to a new author, for believing in my project from the start, and for being such a pleasure to work with.

NEW YORK
CHARACTERS

JOE FRANKLIN

Though most people credit Joe Franklin with inventing the talk show, they often fail to mention his other, far more spectacular invention: himself. Spend time with this living, breathing piece of New York television memorabilia and you'll quickly be asking yourself, "Is this guy for real?" In a city of characters, Franklin just might stand alone.

Born in the Bronx ("When I was born something very horrible happened—I lived"), Franklin started his entertainment career in 1950 at a New York radio station. One day, Channel 7 called and asked him to do an hour on daytime television. Franklin suggested a talk show. "You know, nose to nose, eyeball to eyeball," he says. "They thought I was nuts and said that no one would want to sit around and watch people talk." He defied the executives, and from this rather simple idea, a cornerstone of American culture was born.

For forty-three years, Franklin kibitzed with the likes of John Wayne, Charlie Chaplin, Barbra Streisand, Bruce Springsteen, and Woody Allen. Interspersed with the celebrities were nobodies (a balloon folder from New Jersey!), and whether famous or unheard of, Franklin was the king of heaping unabashed praise on his guests. "Rosie O'Donnell says that she learned all of her hyperbole at my footsteps," he says, beaming.

Joe went off the air in 1993 after a mind-blowing 21,245 shows, but the legend lives on in numerous forms. There's his midnight to five Sunday morning talk radio program; reruns of *Saturday Night Live*'s Billy Crystal's dead-on Franklin impersonation; and a new Times Square restaurant, Joe Franklin's Memory Lane, which tries to capture the magic and ambience of the old Broadway and New York vibes. "The restaurant is like a fantasy," he says. "I go there almost every day. Shake hands, meet the people."

There's also his fabled telephone manner. Franklin, who describes himself as "organic," has never had any agents or managers handling his affairs. Even back when he would get hundreds of calls a day from people wanting to be on his show, Franklin took every call. Today, the phone still rings off the hook, and Franklin's scatterbrained, hilarious answering routine is marvelous. "I have some great news for you. Call back at four. Promise me! It's critical that you call me back exactly at four," he yells into the receiver as he slams down the phone. He tells the next four callers the exact same thing. At 4:00 p.m., he's nowhere to be found.

But nothing keeps the Franklin legend alive more than his office. Crammed to the ceiling with paper, books, photographs, news clippings, and numerous unidentifiable objects, it is simultaneously a heap of schlock and a storehouse of showbiz history. To enter, you must literally walk in sideways, and once inside, you must proceed with great caution through the narrow walkways. One false move could have you trapped in a landslide. There is, however, a method to his mess. "I can have the thrill that a neat man could never have," says Franklin. "The thrill of finding something that you thought was irretrievably lost."

If you happen upon Joe Franklin, you'll feel the exact same way.

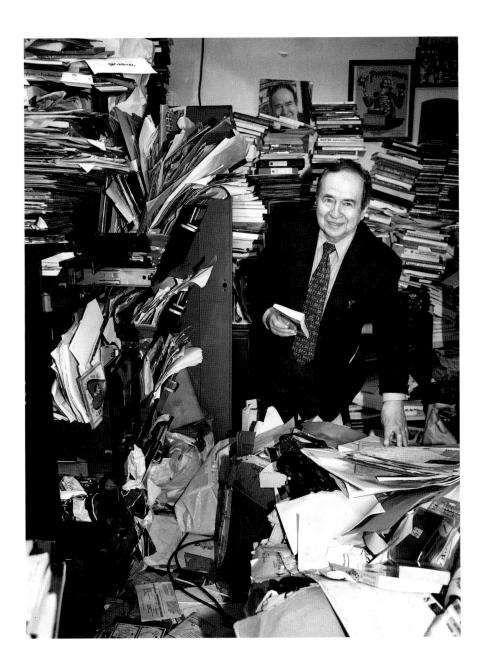

CURTIS SLIWA

Though the New York City subway can sometimes feel more like hell than heaven, it's where a New York Angel got his start. In 1979, Curtis Sliwa founded the Guardian Angels. Originally formed as a citizens group to patrol the number 4 train (then known as the "muggers express"), the Angels have been guarding our city and its people for the past two decades.

Back in the late seventies, with the city on the brink of bankruptcy, Sliwa was working in the South Bronx as a night manager at McDonald's. Each night, he would watch crime victims stumble into the restaurant. "I just got tired of dialing 911 and then seeing apathetic cops arrive," Sliwa recalls. Determined to do something, Sliwa organized the first Guardian Angels patrol to deter crime and, when necessary, make citizens' arrests.

Even with a fiscal crisis and a severe lack of police funding, the city wasn't always behind the Guardian Angels. With their uniform of red berets and black pants, they were often mistaken for just another gang. Mayor Ed Koch was a vocal adversary of the Angels (he eventually converted) and exacerbated their image by calling them "vigilantes." That name, Sliwa says, "stuck to us like a scarlet letter."

But Sliwa persevered, enforcing change not only on the street but also on the airwaves. As the host of a nighttime talk radio program, Sliwa was a vocal critic of the city's ills, particularly the Mafia. It almost cost him his life. In the early 1990s, Sliwa was attacked by a band of bat-wielding thugs outside his Brooklyn apartment and, on a separate occasion, shot five times by a gunman disguised as his cab driver. Miraculously, Sliwa soldiered on, and grew the Angels into an international organization with over five thousand members and twenty-eight chapters around the globe.

But as New York changed, so did the Angels. In recent years, with crime rates at historic lows, the Angels have focused their energy on our city's children, with offshoots Urban Angels and Cyberangels. Urban Angels focuses exclusively on helping children "stay on the right track," while Cyberangels patrols the Internet for child pornographers and other criminal activity. Both, Sliwa says, follow the Angels' unofficial call to action: "Somebody's not doing something so somebody's got to do something." It's a mantra that not even President Bill Clinton could ignore: he honored the Cyberangels with a Points of Light award, the nation's highest volunteer distinction.

This high school dropout from rough-and-tumble Canarsie has come a long way. Today, people treat Sliwa like a hero, patting him on the back as he walks the streets near the Angels' Times Square headquarters. After some difficult years, he revels in the attention. He's a radio celebrity, with a highly rated weekday morning talk show with civil rights lawyer Ron Kuby. Even Mayor Giuliani's a big fan, appointing him to the Cultural Affairs Advisory Commission (the mayor's controversial decency panel) and naming him our quasi-official Stickball Commissioner, a job requiring him to oversee the city's annual tournament. Like the sport he oversees, Curtis Sliwa is a New York original.

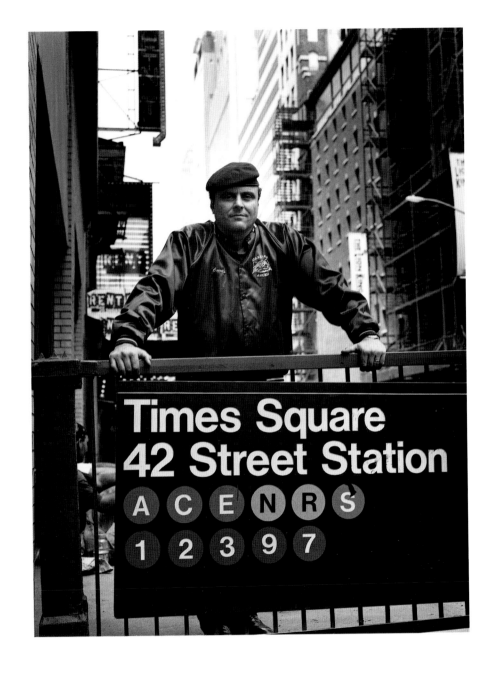

THE VOGELS

"They have a *very* important art collection." This statement, uttered frequently at New York society gatherings, conjures up images of jet-setters traveling the globe, attending fancy parties and exclusive auctions in search of their next great piece. It would not bring to mind a postal worker and a librarian—both retired—living in a quaint, rent-stabilized Manhattan one-bedroom. Yet Herbert and Dorothy Vogel are just that, having amassed, and then given away, a contemporary art collection that would make the jet set drool.

In November 1960, Herbert Vogel crashed a Poconos resort reunion "to meet somebody," and caught the eye of Dorothy Hoffman. Two years later, they married, honeymooned in Washington (visiting the National Gallery), and moved to Manhattan. Herbert took a job at the U.S. Post Office; Dorothy at the Brooklyn Public Library. Her salary went toward the rent; his went toward buying art.

Dorothy explains their beginnings: "Herbert had always wanted to be an artist. He took courses, hung out with other artists, and learned everything on his own. He taught me everything and I soon wanted to be an artist, too. So we got a studio on Seventeenth Street and would paint at night and on weekends. Naturally, we met a lot of other artists and eventually started buying. We soon realized that the other artists were better than we were and gave it up."

But they continued buying. And buying. With astounding vision and foresight, the Vogels were among the first to discover, patronize, and befriend now world-famous artists such as Christo and Jeanne-Claude, Sol LeWitt, Robert Mangold, and Richard Tuttle. "We simply bought what we liked," explains Herbert. "We've never had any rules," echoes Dorothy. "Our only restrictions were budget and size. If we couldn't afford it and couldn't fit it into our apartment, we couldn't get it."

By the early 1990s, their collection, literally piled to the ceiling, began generating serious buzz. Critics and curators started to descend upon the Vogels and their over two thousand pieces of art. The buzz turned into a scream when, in 1992, the Vogels decided to donate their entire collection to the National Gallery in Washington, D.C.

"We always knew we wanted to give our collection to a museum," says Dorothy. "The big decision was where and when." The Vogels liked the idea of gifting to a museum where the admission is free and collections are never sold. "And then of course," adds Dorothy happily, "it's where Herbert and I went on our honeymoon." As for the "when," the museum convinced them that they should do it while they were still alive. "If we were dead," says Dorothy, "we could not experience the thrill of seeing the impact that we have had. We visit the collection a couple of times a year and derive great pleasure from it."

Great pleasure, but not great riches. Art experts agree that the Vogels could have easily made multiple millions by selling off their collection, but they never sold a single piece. "We didn't do it for the money," says Herbert. "I never made a twenty-dollar bill from selling art. That was never our ambition." Their ambition was simply to pursue a life's passion that they now share with others—for free.

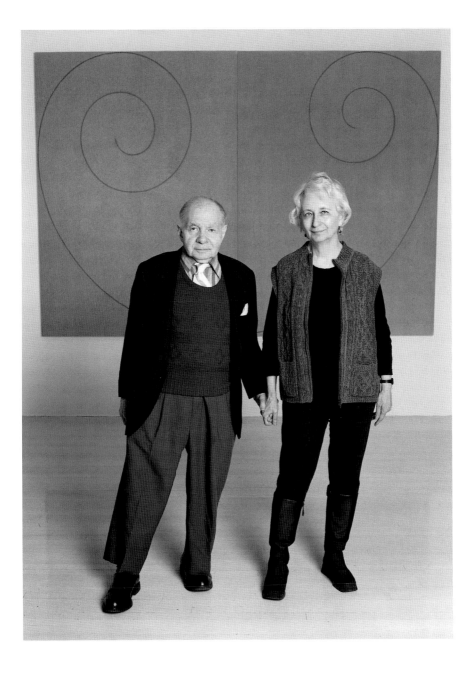

FIREMAN ED

"J-E-T-S. Jets! Jets! Jets!" No, that's neither a description of La Guardia's overcrowded runways nor a lyric from *West Side Story*. Instead, it is New York's most famous, loudest, and most-blood-pumping football cheer, emanating from the mouth of New York's most famous, loudest, and most fanatical football fan, Fireman Ed.

Dressed from head to toe in Jets regalia with his trademark Jets fireman's hat, Ed Anzalone has been firing up Gang Green's faithful for the past seventeen years. "When the Jets moved from Shea Stadium to the Meadowlands in 1984, the crowd was not nearly as vocal or as crazy as they had been," recalls Ed. "So I had to take matters into my own hands." The rest is New York football history.

Officially recognized by the Pro Football Hall of Fame as the Jets number one all-time fan, Fireman Ed, a real-life fireman for Harlem's Engine 69, supports his team like it's his job. Though his season ticket is in section 134 of the Meadowlands, Ed travels up and down the stadium keeping the crowd fired up. He spends a lot of time on the shoulders of his brother, Frankie, who lugs Fireman Ed's six-foot, two hundred–pound frame up and down the stadium throughout the game. ("Strongest guy I've ever seen," remarks Ed.) Before launching into the J-E-T-S cheer, Fireman Ed, through impassioned histrionics, literally brings the entire stadium to its feet. "Football's a mental sport," he explains. "So I always do the cheer at the beginning of the game and then just react to the feeling of the crowd."

But sometimes Fireman Ed feels more than just the crowd. Since he's become a significant sideshow attraction to the goings-on on the field, Ed occasionally gets a case of the nerves. "I often throw up before the game," he confesses. "Not every game, but, I mean, I get butterflies—it's like I think I'm playing." And why not? Some see his role as crucial to the team's success. Even Al Groh, the Jets current head coach, recognizes Ed's impact, and has called Ed at home to tell him so.

With so many Jets faithful roaming New York's streets, Ed's treated like a celebrity around town, a role he grudgingly accepts. "I'll wear glasses and a hat when I don't want to be recognized," he explains. The Jets have even asked him to come onto the field with them, but he's declined the invitation. "It's a nice honor," says Ed. "But I'd rather stay in the stands with the fans who made me what I am." And any money he makes from his luminary status goes straight to charity. Clearly, this is a guy who hasn't let fame go to his helmet.

"This is not something that I planned," Ed says a bit sheepishly. "This all came about from just going to a football game and from loving the game that I love." He'd love it even more if his two dreams came true: if the Jets won the Super Bowl (they won it pre-Ed in 1969) and got their very own stadium. "I hate Giants Stadium and I hate the Giants," he bluntly exclaims. And in this regard, this superfan is no different from the rest of his Jets-loving brethren.

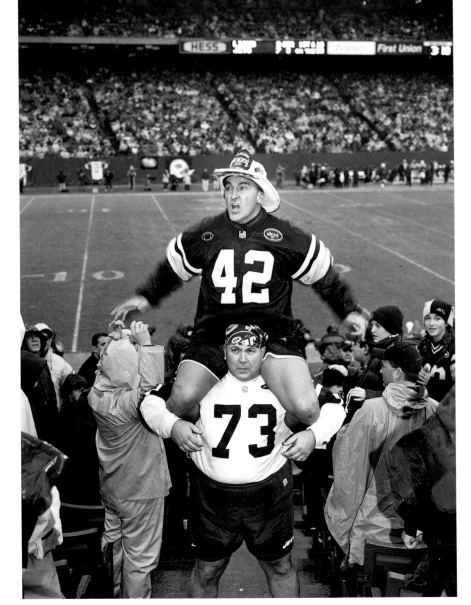

YOLANDA VEGA

Lottery tickets in hand, thousands of New Yorkers gather around their television sets each night to match their numbers against the ones on those airblown Ping-Pong balls. Almost all, of course, go to bed disappointed, with dreams of early retirement quashed by a digit, or two, or three. But somehow, Yolanda Vega, the bearer of this bad news, always manages to bring a smile to their faces. You've never heard of her? Well, if not, then maybe you've heard of Yo-LAHNNNN-da Vega, the unabashedly bubbly announcer for the New York Lottery.

"I like to think that people are drawn to my personality and enthusiasm for the job," says Vega, who is as delightful as she appears on screen. "I'm happy with what I do and I think it shows." She acknowledges, however, that some people think she's so popular because of the way she says her name. Whatever the reason, there's something about Yolanda. While she shares her lottery-announcing responsibilities with four other women (she appears roughly twice a week), she's the only one who's appeared on *The Oprah Winfrey Show* and had her very own contest—the "I Want to Be Yolanda Vega" sweepstakes—named after her.

Born and raised in Brooklyn, Yolanda moved to Albany when she married Miguel Vega, a state trooper. Armed with an economics degree from Hunter College, she found a bookkeeping job at a bagel shop. When she heard the lottery was holding auditions to become an announcer, Yolanda took a gamble. Because of her husband's odd hours, she was often alone in the evenings and thought lottery announcing might be fun. "I went to the audition and was so nervous," she recalls. "I barely even knew how to apply makeup. I think my eyeshadow was blue back then. I read the script, talked on and on about myself, and left thinking I'd never get the job."

Eleven years and thousands of drawings later, Yolanda Vega is more than just a household name. "Women have told me that the first word out of their babies' mouths is 'LAHNNNDAV-EGA,' " she says incredulously. "It's crazy." In spite of her widespread name recognition, she's hardly living the life of a glamorous television star. "As a full-time state employee, I have to work my thirty-seven and a half hours," explains the Brooklyn native without apology. "So I do it all, whether it's helping set up the stage for the drawings or answering phones." You think Vanna White helps pick up the phones?

Still, there are many perks to her job. "The best part is getting to meet people all over the state," she says with the same enthusiasm with which she announces her name. "I *love* all the charity work we do and I especially *love* speaking with young children." Though recognized all over New York, Vega, who lives in Schenectady with her husband and their two daughters, does not consider herself a celebrity. "I always go out in public with no makeup on and my hair up in a ponytail," exclaims this anti-diva. "I still bowl and still shop at Wal-Mart."

But wherever she goes, people stop her and beg her to say her name. That's because Yo-LAHNN-da Vega's captured the hearts of every New York lottery player, even if she doesn't have their numbers.

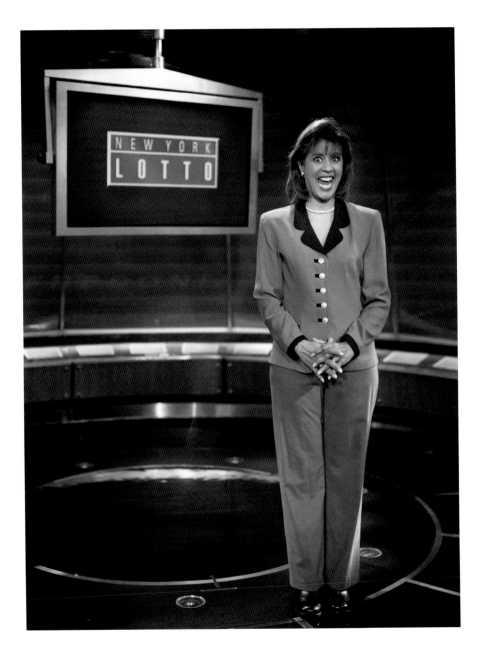

THE LEMON ICE KING OF CORONA

As the Lemon Ice King of Corona, Peter Benfaremo rules over his street corner fiefdom with a starched white hat and an iron fist. Though his delectable desserts bring great joy to ices-loving New Yorkers, Benfaremo dispenses them with the tough-guy authority of a man handing out parking tickets, not frozen sweets. As this King of Queens explains: "I won't insult you unless you give me a problem. There's simply one rule here that everyone must respect." Pointing to the prominent red-lettered sign just above his head that is almost as famous as the ices themselves, Benfaremo emphatically reads out the boldfaced type: NO MIXING FLAVORS.

The Lemon Ice King of Corona may offer twenty-nine flavors, but according to the King's royal edict, everyone—even the Mets (who often come from nearby Shea Stadium)—must be content with just one. As Benfaremo says: "Why you gotta mix for?" His philosophy, fine-tuned over a half century in the business, isn't complicated: "You are paying for an ice. What is this garbage of mixing a banana with a strawberry? What kind of combination is that? Whhhaaat is thaaattt? What are we children here? This is a high-class type of merchandise and should be enjoyed in its regular form. Banana? Banana. Strawberry? Strawberry. Banana-strawberry? That's crazy! You don't taste one and you don't taste the other."

Benfaremo has been in the business since 1945, when he joined his dad behind the counter immediately after returning from World War II. "It was a small little place, one man making ices in the summertime," says the King. "But after I joined the business I slowly elevated it to the state it is in today." In those early days, there were only lemon and pineapple ices, but each year the King expanded the menu a little. "I wanted to make it a little more interesting, so I added flavors: chocolate, cherry, fruit cocktail, pistachio—but that was fifty years ago. Today, I don't need to make up any more recipes. I just use what I've got: twenty-nine flavors. That's enough."

And it's also enough for the faithful who still line up around the block on summer evenings, as they have for half a century. In fact, not much at all has changed in those fifty years. For Benfaremo, this—like most everything else having to do with ices—is a matter of principle. "Everything in this place is the same," he says. "Even the jars on the shelf have been here fifty years. As long as you keep the place the same, then people will always say, 'It's the same place, same guy, same merchandise.' I do the best I can for my customers." Unless, of course, they ask for a double scoop of coffee and coconut. Fuhgettaboutit!

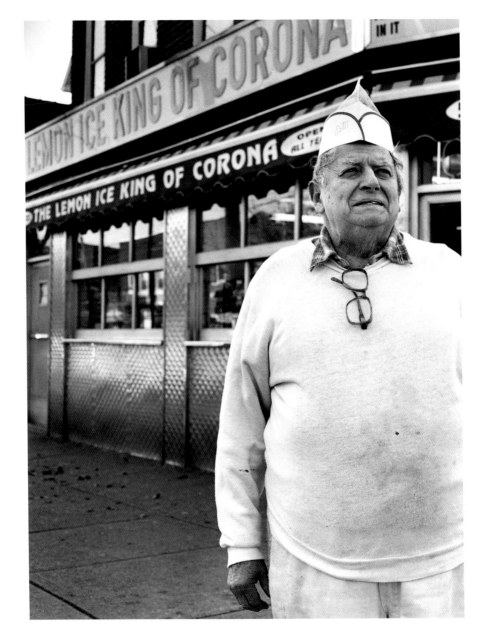

RADIO MAN

Don't let the name fool you—Radio Man is all about the movies. With a radio strapped around his neck and a goofy bicycle to get him around town, Radio Man has propelled himself into the heart of New York's movie culture, becoming a mascot of sorts for stars and star-stalkers alike. He spends his days riding his bike between movie sets and celebrity gatherings, hanging out with the paparazzi and waiting for the moment he craves: when the stars turn their gaze on him and, more often than not, yell: "Hey Radio Man!" Celebrities might not give the paparazzi the time of day, but when they see this eccentric Brooklyn native, a.k.a. Craig Schwartz, their matinée-idol eyes invariably light up. "It's a one on one thing with the stars and Radio Man," one reporter said. "He knows them *and* they know him."

Radio Man has made a career out of following fame around the city, and as a result, fame has followed him a bit, too. He trades gossip with the paparazzi, sharing who's going to be where and when. He collects this information and puts it all on his own hotline, which he updates daily from his travels among movie sets. "Everybody calls Radio Man's hotline," a photographer said. "We all know the number by heart." To make money, Radio Man sells autographs and works as an extra in movies (although, considering his fame, it's more like having a cameo). With his trademark radio and bicycle, Radio Man has strolled on screen with Mel Gibson, Al Pacino, Sylvester Stallone, Goldie Hawn, and countless others. Some stars have really taken to him: Whoopi Goldberg gave him his green Schwinn bike and once flew him out to the Oscars.

Radio Man got his big break ten years ago, while selling newspapers on a street corner. When a film crew came around to shoot a movie, they asked him to move, and when he refused, they decided to put him in the movie instead. The camera's seduction never wore off—he's been roaming the movie sets of New York City ever since.

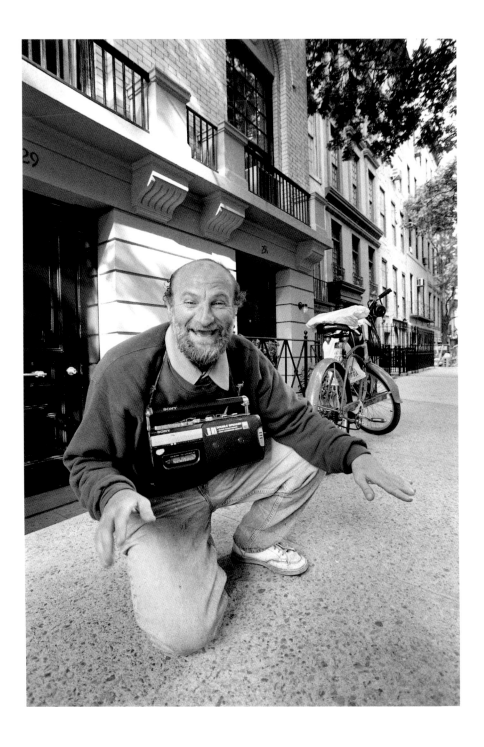

THE URBAN SHEPHERD

This never happened in the *Odyssey*, but it happens every day in Hell's Kitchen: Our hero—a small, powerfully built Greek immigrant named Harry Theodore—leads his flock of hunting dogs home to dinner as the sun sets over New Jersey. "Stasi!" he yells in Greek, and the dogs come to a halt around the cooking fire, where meats are being grilled on a reused refrigerator rack. For appetizers, they gnaw on stuffed grape leaves scavenged from a Times Square salad bar. Cops and conventioneers from nearby Javits do double takes when they see this man with his beautiful dogs sitting down to dinner in a parking lot on West 36th Street. It's as if Hell's Kitchen were the Greek countryside, Javits an ancient temple, and Harry Theodore our local shepherd.

Together, Theodore and his dogs cut quite the figure: with their close-cropped hair (Theodore's is gray; the dogs' chocolate brown) and distinguished gait, they march in formation through the streets of Manhattan. He is like the Pied Piper of Hell's Kitchen, with a wooden staff instead of a flute, mesmerizing his pack of twelve perfectly trained dogs. "I speak to the dogs in German, Greek, English, and Spanish—they are fluent in every language," Theodore explains.

Evenings are spent searching for food, scavenged from the trash of midtown restaurants and delis. Theodore has this down to a science—he knows exactly when the best trash hits the sidewalk and follows a carefully planned route. He must collect thirty pounds of food each day, resorting to canned dog food only when necessary. The community often helps him, bringing food and sometimes money to the parking lot. In the winter, neighbors will often find Theodore and his dogs piled on top of one another for warmth near the garbage heap that fills the back of the lot.

His T-shirt may be dirty, but the dogs' coats are immaculate—these are purebread German shorthaired pointers, which typically cost about $2,500 from a breeder. Theodore's been breeding pointers since the 1960s, when he was given two by a friend. He will sell the dogs when he can, but only if he thinks they're ready. He once turned down $500 for a puppy because it hadn't been weaned.

But Theodore's time as the city's only working shepherd may be coming to an end. Since arriving in New York as a teenager in 1952, he's bounced around the city's neighborhoods working odd jobs and living in temporary housing. Living on the lot since 1997, he has been waiting for a subsidized apartment (where he would only be allowed two dogs) for years. But if he can muster the money, he has bigger plans for himself and his dogs: they'll pack up a van and head for the country. "It will be better for them there," he says wistfully, standing amidst his breathtaking dogs. "There are greener pastures."

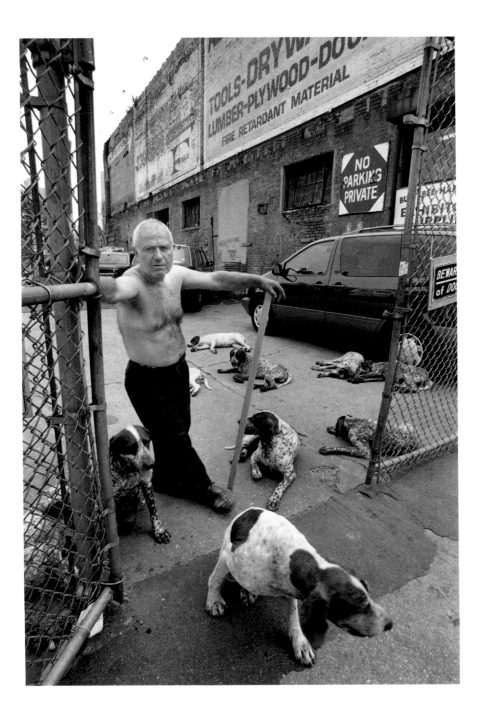

LADY BUNNY

It's your prototypical New York story, with a twist. Country boy from Chattanooga, Tennessee, constrained by the provincial ways of his small southern town, itches to leave. One day, he hitches a ride with a rock band headed for the Big Apple. The musicians tell him he can come along, under one condition: he must entertain them by dressing in drag. Already predisposed to wearing dresses, the boy happily obliges and along with the rockers makes his way up north.

Twenty years later, this country boy is Lady Bunny, the nation's number one drag queen (as voted by *Genre* magazine—"it's not like it's the *New York Times* or anything," she laughs). Lady Bunny is the founder and grand dame of the annual Wigstock Parade, the most fabulous event in town. "I have about forty wigs," brags the hilarious Lady B. "They're strewn all over my floor. I'm usually in drag three or four times a week—sometimes for work, sometimes for dates."

Wigstock's origins begin at the East Village's Pyramid Club, *the* drag hangout in the eighties. Late one evening in 1984, Lady Bunny and a drunken group of friends closed down the Pyramid Club and stumbled over to Tompkins Square Park, six-packs in tow. No one remembers who, but someone came up with the idea of starting a day-long drag festival and calling it Wigstock. Everyone either laughed the idea off or was so hungover that they forgot about it. But for Lady Bunny, it was an epiphany. She took the bull by the horns, or the queens by their wigs (including RuPaul, her ex-roommate), got the necessary permits, and began what has become a glorious New York tradition.

Wigstock has grown larger than its founders could ever have foreseen: the annual one-day vaudeville is the most visible dragfest in the country, with thousands of spectators. And just like the festival upon which it is based, there's a Wigstock movie, an album, and a forthcoming book. And Lady Bunny is the belle of the ball. "There's just a very positive vibe to it all," she exclaims. "It's as simple as let's put on a show and have a party!"

Which seems to be Lady Bunny's take on life. A buxom blonde when she wants to be, Lady Bunny is as large in person as her personality. It's hard to tell which is bigger—her wigs, her five-inch heels, or her nails, but it's all part of a powerful persona. With a nightclub act that she's taken around the world, regular DJ gigs in the city, and numerous television appearances, Bunny's always expanding her brand.

Recently, she's even chartered some unknown waters. "I do corporate parties—even weddings," she says, laughing. "Can you imagine that happening twenty years ago? It would have been like having a pervert freak ruining your entire wedding. Now they all run over to get their picture taken with me. It's a sign of the times."

Will the Queen of the Queens ever leave Manhattan? "I didn't leave Chattanooga to move to New Jersey," she croons. "I bitch about the apartment drama, but I've still never been anywhere else with such sustained excitement. And to be able to get a taxi on any corner is essential. I'm not going to take public transportation dressed like this!"

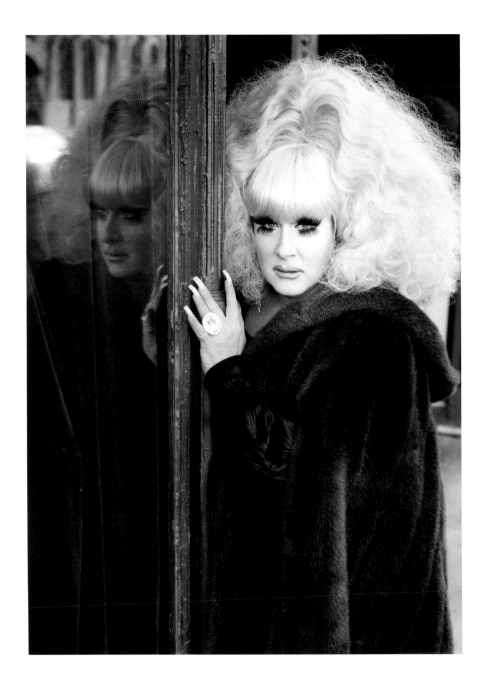

DON IMUS

Each weekday morning well before dawn, an old cattle rancher with curly hair and rugged features emerges from his Upper West Side apartment building. Instead of mounting his horse, he enters a chauffeured car, in which he trots crosstown, gallops over the 59th Street Bridge, and dismounts at his Long Island City offices. This early-rising urban cowboy is none other than Don Imus, whose vastly influential radio show has been entertaining, educating, and provoking its listeners for the past thirty years.

John Donald Imus spent his early career far from the easeful life he now leads. After what he calls a "horrible" adolescence in California and Arizona, Imus worked as a window dresser, rock musician, copper miner, and railroad brakeman before finding himself and his voice as a disc jockey. After stints in minor league markets in Palmdale, California, and Cleveland, Ohio, he made his way to the Big Apple, where *Imus in the Morning* debuted in 1971.

From the start, Imus was instantly sharp-witted, controversial, and a major hit. In so doing, he became radio's very first "shock jock." (Howard who?) "When I came to the city, what I was doing was shocking," says Imus, who mixed music with his unique brand of "insult humor," satirizing and parodying everything in sight. "Nobody had ever heard stuff like that on the radio. I wasn't swearing but it was pretty close. We were the first to ridicule people in a way that made them uncomfortable."

But how did this popular New York DJ with a penchant for vitriolic banter transform himself into the most powerful radioman in the nation? After wrestling with alcohol and drug abuse throughout much of the seventies and eighties, Imus put his addictions behind him and remodeled his show. In 1987, he dropped the music format, went all-talk, and began to attract serious-minded guests, from politicians (Bill Clinton, John McCain) to authors (Anna Quindlan, David Remnick) to the leading newsmen (Tom Brokaw, Dan Rather) of the day. Though the guests are serious-minded, Imus is still his irreverent, caustic self, insisting that it's not a serious political show. "We simply revel in the agony of others," he says, laughing.

These days, New Yorkers must share Imus with the rest of the nation. His radio potency stretches far beyond the frequency of WFAN, the New York station from which he broadcasts. Reaching over 15 million listeners on some 100 stations around the country (not to mention about 200,000 viewers on cable television's MSNBC, where his radio show is simulcast), Imus is now firmly entrenched in our national discourse. In the past few years, *Newsweek* put him on its cover and *Time* named him one of its twenty-five Most Influential Americans.

These days, Imus devotes much of his time to children's charities, raising millions of dollars for pediatric cancer research and sudden infant death syndrome (SIDS). He is most proud of his Imus Ranch in New Mexico, which provides children with cancer and SIDS siblings the opportunity to experience life on a real working cattle ranch. "All my vacation time is spent on the ranch," says Imus, glowing. "Teaching kids to ride horses is like a vacation to me." While you wouldn't guess it from listening to his on-air rants, Imus is about as big-hearted as they come.

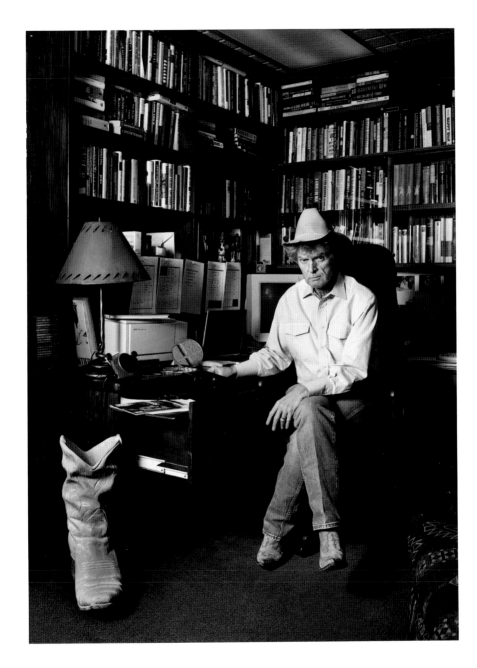

ELAINE KAUFMAN

New York society has many well-recognized status symbols. A Fifth Avenue penthouse (preferably with a park view). A house in the Hamptons (preferably south of the highway). Courtside Knicks tickets (preferably next to Spike). A spot on a museum board (preferably MoMA or the Met). But perhaps more than any of these tokens of influence, a regular table at Elaine's confers A-list status like nothing else. For thirty years, Elaine Kaufman's eponymous Upper East Side restaurant has been home away from home for the city's literary and social elite.

How did this woman, born to Russian Jewish immigrants in northern Manhattan and raised in the outer boroughs, become salon keeper to the city's beau monde? The legend of Elaine's started in 1959 in Greenwich Village, where this budding restaurateur opened her very first establishment, Portofino. After building up a following downtown, Kaufman moved to the Upper East Side. "The real estate was cheap," she recalls in her typically blunt manner, "so I moved."

Downtown or uptown, Elaine filled her tables with journalists from the city's newspapers and *The New Yorker*. These young writers sought refuge at Elaine's, which provided an atmosphere where they could unwind and surround themselves with like-minded literati. One scribe led to another, and before she knew it, she was the belle of the belletrists. As the late southern writer Willie Morris put it, " . . . in my years in New York in the 1960s and 1970s, this was the clubhouse, giving us in the throbbing metropolis the warmth and togetherness of a small town."

Over the years, Kaufman's famed clientele has expanded well beyond men and women of letters. The highbrow set has been forced to share the restaurant with actors, musicians, athletes, politicians, and just about anyone else who finds their name in a tabloid gossip column on a semiregular basis. One group of patrons that Kaufman's downright passionate about is her beloved Yankees. "The Yankees are my life," says the proud fan, who has hosted dinners for the Bronx Bombers and fed her pal George Steinbrenner for the past twenty-five years. She's also gone Hollywood, hosting New York's hottest Oscar party each year for the unnominated movie types stuck in New York for the Academy Awards.

The unimportant among us who go and check out Elaine's are usually surprised by the restaurant's no-frills atmosphere. Inconspicuously located on Second Avenue between 88th & 89th Streets, Elaine's looks and tastes like any number of good Upper East Side Italians. But when you look at the walls, filled with memorabilia from its regular patrons (a Woody Allen movie poster, a George Plimpton book jacket, a Mike Nichols play program), you get a sense of Elaine's landmark status.

If you ask Kaufman who the regulars are, she demurs. "If I say one and not the others, they will get jealous," she laughs. "But other than some tourists, almost everyone at my restaurant are people that eat here all the time."

One person who eats and drinks there all the time is Elaine herself, cavorting with her clientele throughout the evening (many are close friends). Whether she's at the bar consoling an author with writer's block or at one of her regular tables gossiping the night away, Kaufman works the room like she owns the place.

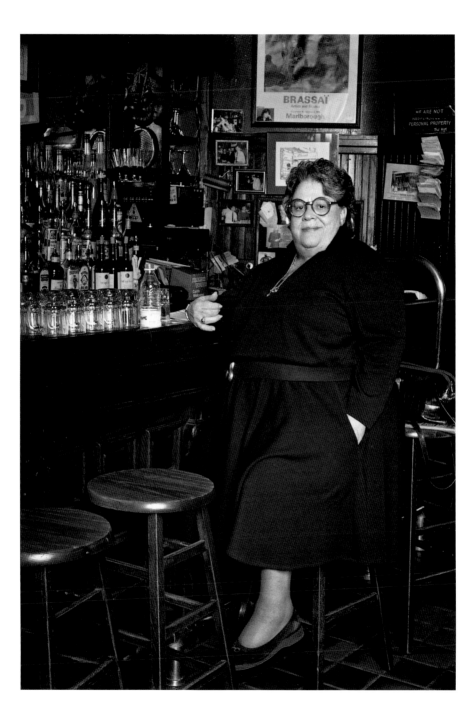

POLAR BEAR CLUB PRESIDENT

Perhaps jumping into the frigid Atlantic Ocean in the dead of winter does not sound like your idea of a good time, but for Ken Krisses and the other members of the Coney Island Polar Bear Club, it's what they look forward to all summer long.

Every Sunday, from mid-September till mid-May, Ken Krisses migrates from his home in Staten Island to the beach at Coney Island. As president of the club, Krisses bears responsibility for preparing the day's festivities. The first thing he does is plant an American flag in the sand. "What we are doing is a great American tradition," he proudly explains. Ken then unlocks the clubhouse (which doubles as a lifeguard station during the summer) and sets up a propane heater inside, keeping close tabs on the room temperature so it doesn't soar above a whopping 50 degrees. One by one, the Polar Bears begin to arrive and boldly change into their bathing suits. The fun is just about to begin.

Ken swings the door open and leads his group out into the biting cold air and down the long stretch of beach to the water. Pre-plunge, the group forms a circle and Ken attempts to get their heart rates up by leading them in about five minutes of calisthenics. Then it's into the water they go. Another circle is soon formed and, as they bob up and down, the members yell in unison: "Summertime! We're Polar Bears!" Usually there are spectators around telling them that they are crazy. "I don't even bring a towel," Ken says. "I just run up and down the beach to dry off."

The Polar Bear Club was founded in 1903 by a well-known publisher and health enthusiast named Bernarr Macfadden (whose other physical exploits included annual parachute jumps on his birthday well into his eighties). His belief was that cold water swimming is good for you; the club still adopts this philosophy. "The colder the better as far as the water is concerned," boasts Krisses. "Other clubs sometimes cancel because it's too cold—we never do. Sometimes we even come out covered in ice, but we enjoy it and we don't get sick." There are about fifty members of the club, but on any given weekend about twelve to fifteen show up. The members, both men and women, come from all over the tristate area and are from all walks of life. "We've got everything from business executives to construction workers; but when we get to the beach, we're just one big happy family."

If joining that big happy family does not quite tempt you, the Polar Bears' annual New Year's Day swim—open to the general public—might be a good time to at least get your feet wet.

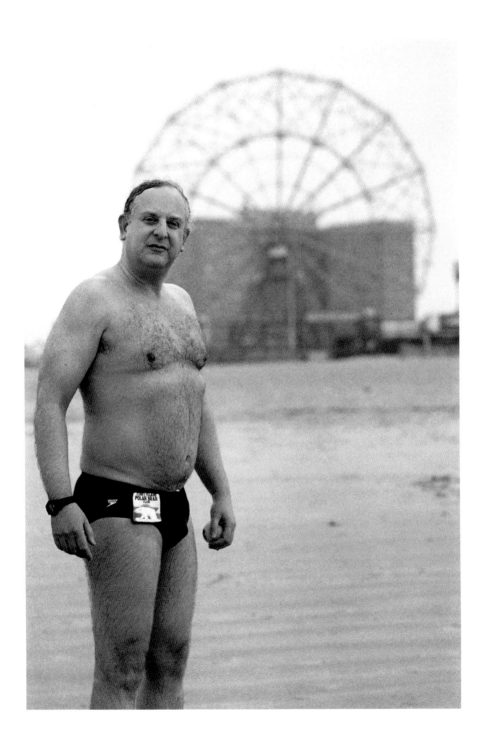

THE OLDEST CABBIE

In a city that sometimes seems to have more taxis than people (except when you really need one), it's hard to be a standout cab driver. Unless, of course, you're Johnnie Footman. Footman does have a near-spotless driving record (he's gotten just one ticket while behind the wheel and never had an accident), but it's another kind of record that he can lay claim to. Because, born in 1919, Footman is almost certainly the city's oldest taxi driver. And while the Taxi and Limousine Commission cautions that they don't keep track of drivers by age, no one has stepped forward to challenge his claim. And why would they? By all accounts, Footman is the nicest cabbie you'll ever tip.

Footman isn't only adored by his passengers, he's also the big wheel in the garage. The Spider, as he's called, arrives early to work with a cup of coffee in one hand and a cigar in his mouth, and shmoozes with other drivers and mechanics until they force him into his cab. "People complain about how hard it is to drive a New York City cab—but Johnnie shows you that if your attitude is right, any job can be great," remarks the garage manager.

A lot of Footman's attitude comes through in his unique take on professional attire. Every day he wears a tie, a baseball cap, glasses with flip-up shades, and a ratty tweed jacket. "I like ugly coats," he explains. Consequently, hopping into a cab with him almost feels like getting into a time machine. Not surprising, when you consider that he got his taxi license in 1945. And while Footman's seen a lot of change in the cabs that have been his office over the years, the biggest change, he says, is in the passengers. "Passengers are bossy," he complains. And they tip less and less well.

Still, Footman doesn't seem strapped for cash. And although he's been receiving his union pension since 1984, Footman doesn't have any plans to retire, either. "There's nothing else for me to do—it's part of me now," says the octogenarian on wheels. Still, for obvious reasons, Footman has scaled back his driving somewhat in his later years. Since drivers have to rent their cabs by the day, most cabbies try to get in as many trips as possible (usually upwards of forty), but Footman stops after his twenty-fifth "drop" of the day, and he only drives four shifts a week. He even tries to avoid long trips by literally acting crazy whenever someone wants to go too far away. Usually, he says, they get out.

But for those who are one of the lucky twenty-five each day, the Footman drive is a real trip. And after over a half decade of driving New Yorkers around, Footman still loves his side of the job, too. "My plan is to just keep driving till I get tired," the grandfather of New York taxis proclaims. A cabbie for over fifty years, and still not a dent in his fender—they don't make 'em like they used to.

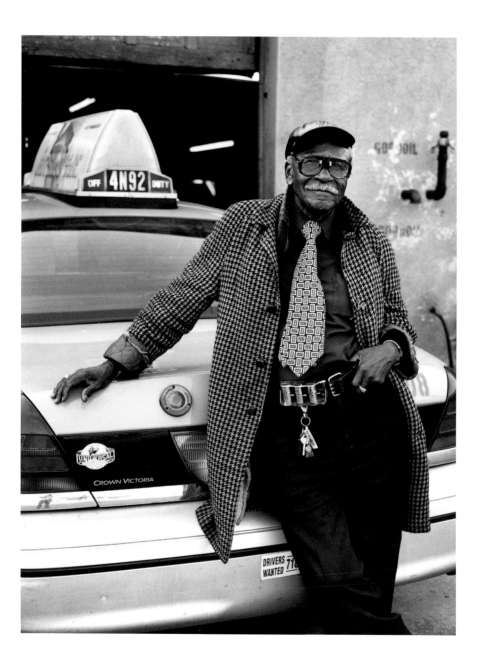

HOOP

It's difficult to excite a bunch of jaded New Yorkers when it comes to automobiles. In a city where thousands of yellow cabs and noisy oversized buses dominate the streets and most New Yorkers walk or take the subway, we're not exactly what you would call a driving culture. But Stephen "Hoop" Hooper and his automobiles make even the most world-weary New Yorkers turn their heads. Hoop is our resident artist-in-traffic, a sort of mobile expressionist of the art world.

It started almost twenty years ago, when Hoop, who looks as if he jumped off the pages of a Dr. Seuss book, covered a whole Packard hearse in vinyl leatherette. But then fate intervened. "One day I got in an accident and crunched out the front," he recalls. "So I found this purple faux fur material and used it to cover all the dents." The end result was an abstract automobile sensation. While not quite Picasso on wheels, on that day an artist was born.

These days, most of what Hoop puts on his cars is more calculated than purple fur. In fact, his cars are always thematically and wittily decorated. There is the Millennium Machine, with clocks all over it ticking toward the new year. And the Good Luck Truck, decked out in horseshoes and four-leaf clovers. Another of his creations, Spin Art, is covered from axle to roof in shiny CDs and records. "I have things that actually spin (like records and CDs)," he explains, "and other things that spin like telephones and media devices—you know, things that *create* spin."

When not behind the wheel, Hoop has also been known to dabble in performance art, like the time he stuck his head and hand out of a buffet table at a party ("People thought I was just another platter of junk food!"). He's also gathering what is sure to be the most important collection of blown-up fingerprints of famous people.

With his eclectic artistic tastes, Hoop is quite the Renaissance man. But he's come up with a better, slightly less humble title for himself—"The self-proclaimed King of Art." The epithet, of course, is tongue-in-cheek, but there's a point to the proclamation. "If I ask a guy walking down the street to name any living artist, he would most likely give me a blank stare," laments Hoop. "It's a sad commentary on today's art community." So Hoop has seized what he considers the empty throne, and with the attention he receives, he thinks his title just might catch on. "When I'm out and about with my cars I get very good reactions," he reasons. "On a nice summer day if I don't get my picture taken every minute, then I'm just not doing my job as the King of Art."

Ever the attention-getter, you will frequently find him parked outside the hot art scene of the moment, whether it's an opening at a Chelsea gallery or a new exhibit at an uptown museum. His intentions are pure. "My goal is to simply expand the art world a little," says Hoop. "I just want to bring more attention to it, and to me, of course."

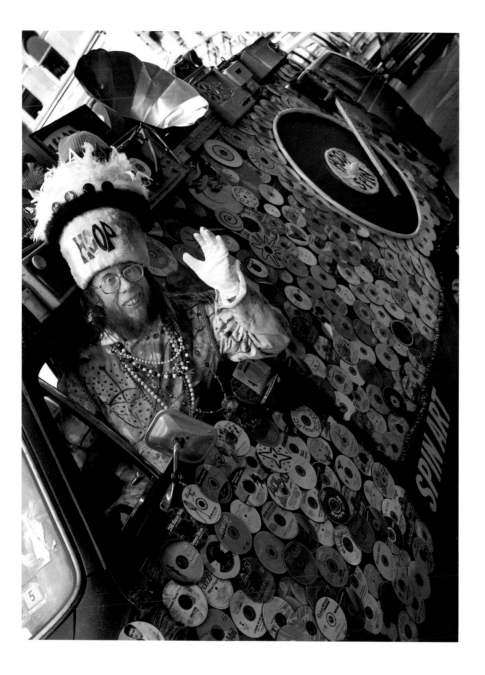

YOGI BERRA

Yogi Berra, our beloved baseballer, was once asked by his wife, Carmen, "Yogi, you are from St. Louis, we live in New Jersey, and you played ball in New York. If you go before I do, where would you like me to have you buried?" "Surprise me," Yogi responded, displaying his talent for the legendary one-liner.

If we New Yorkers had our say, we'd unanimously vote for a Bronx burial, somewhere beneath Yankee Stadium. Through three decades, Berra made history not in St. Louis (where he was born Lawrence Peter Berra), not in Montclair, New Jersey (where he's resided for forty years), but in The House That Ruth Built. As the nucleus of the sport's greatest dynasty— the New York Yankees—Berra became a fifteen-time All-Star, three-time Most Valuable Player, and helped his team win ten world championships. He's widely considered one of the greatest catchers in the history of the game.

But to highlight only Yogi Berra's baseball exploits would be like writing about O. J. Simpson and only mentioning his football career. No, Yogi has never been in trouble with the law; in fact, most think of Yogi as one of the nicest, most down-to-earth athletes this city has ever seen. What distinguishes Yogi from the rest of us, beyond his Hall of Fame baseball career, is his stature as the most quoted New Yorker of all time. From Yogi's most well known sayings ("It ain't over till it's over"; "When you come to a fork in the road, take it") to some of his more obscure proverbs ("You can see a lot just by observing"; "Nobody goes to that restaurant anymore; it's too crowded"), Berra has consistently delivered priceless pearls of wisdom the same way he delivered clutch hits for his beloved Yankees.

"I never said most of the things I said," explains the stocky Yogi, who got his name from a childhood friend who thought he looked like a Hindu snake charmer in a movie they had seen. But he did do all of the things that he did, which includes serving in World War II on a boat that capsized off Omaha Beach during the D-Day invasion. Yogi also did stints as a pennant-winning manager of both the Yankees (1964) and the New York Mets (1973). His managerial success certainly came from his firm belief that "baseball is ninety percent mental; the other half is physical."

After being dishonorably discharged as Yankees manager by owner George Steinbrenner just sixteen games into the 1985 season, Yogi refused to return to Yankee Stadium for fourteen years. In 1999, he and George buried the hatchet and Yogi reembraced the franchise and the city that had never stopped loving him . . . and his quotes. If you asked him about the Steinbrenner episode, he just might deliver one of his many classics: "If the world were perfect, it wouldn't be."

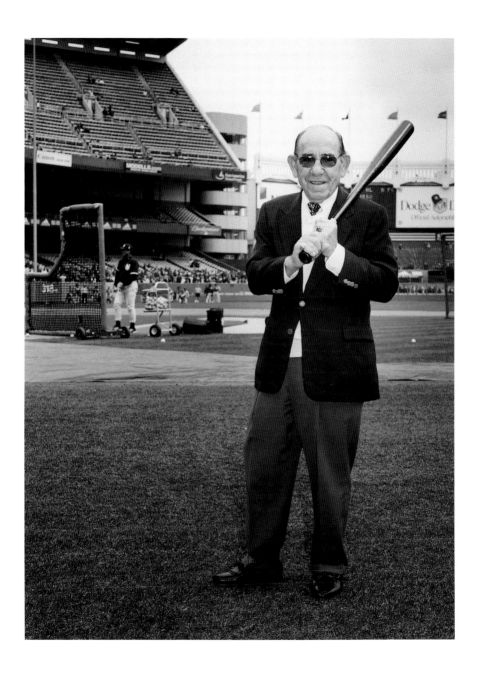

"Mayor" of the Reservoir

Central Park's celebrated reservoir means different things to different people. For some, it is merely an artificial pond used to store the city's water supply. For others, it is a scenic, serene 1.57-mile loop, a refreshing escape smack dab in the middle of New York's urban jungle. For Alberto Arroyo, it's life.

Arroyo is the "Mayor" of the Reservoir, using the famous track as his personal health club for over six decades. Arroyo never—excuse the pun—ran for mayor. It's just that one rarely runs around the beloved track without an Arroyo sighting. For Arroyo, the reservoir is his very own office. Each day, Arroyo arrives at the reservoir's gatehouse benches by 8:30 a.m. and starts greeting his fellow runners. He kibitzes with and befriends everyone, from the Fifth Avenue executive getting in his morning workout to the homeless person looking to escape the harsh city streets. "Everyone is the same when they are on the dirt," philosophizes the preternaturally cheery Arroyo.

Arroyo came to New York from Puerto Rico at the age of nineteen with dreams of becoming a boxer. A friend told him that the reservoir's ring was an excellent place to do his roadwork. For most of his life, Alberto jogged approximately twenty miles a day. When he first started training, he would jog in his work boots, but has kept pace with the times and now wears Asics running shoes. Over the past fifteen years he has slowed down; he now walks six to eight miles around the reservoir. Not bad for a guy born in 1916.

He is not only recognized within the confines of Central Park. In 1985, the New York State Senate passed a resolution honoring Alberto for making pioneer contributions to the modern fitness movement. Similar thanks have come from officials in Washington, D.C., and San Juan, Puerto Rico. The New York Road Runners Safety Patrol has made Alberto an honorary member, and on the reservoir gatehouse walls there are plaques and photos of him. (In 1993, Arroyo also spearheaded an effort that raised nearly $100,000 to renovate the reservoir track.) All of this recognition is testament to the inspiration that he provides the hundreds of people who jog around the reservoir each day. "Some people really think I am the mayor." Alberto laughs. "They complain if they see garbage, or if they have a problem, they expect me to fix it."

Although most people view the reservoir as a one-and-a-half-mile circle around which they can get some exercise, Alberto Arroyo has used it for much more. He loves everything about the loop around which he has not just exercised but really lived his life. He finds new wonders at every turn. After over almost seventy years, he's gotten "just a little attached."

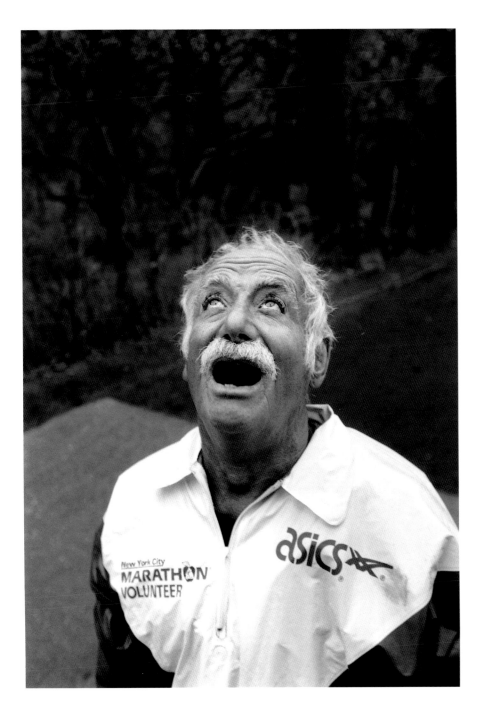

EDGAR OLIVER

Pay a visit to the East Village's macabre poet, playwright, and performer Edgar Oliver, and you're not sure whether you're visiting him at home or on the set of one of his ghoulish plays. The eerily eccentric Oliver lives in a decrepit, deserted town house on Tenth Street with his two black cats (of course!), Lucius and Nefer. With no doorbell or buzzer, you must pound wildly on the door in the hopes that he'll hear you. "Welllcommme," Oliver gestures as you enter the vacant building before heading upstairs to his creepy attic apartment. As for why he's the only one living there, "I am the last of the boarders," he proclaims. "The others, one by one, either died or were carted off to asylums."

You think he's joking, but you're not quite sure. With looks bearing a vague resemblance to Count Dracula and a voice that is a haunting mix of Transylvanian, British, and Georgian accents, Oliver has achieved cult hero status performing his own Gothic plays around his neighborhood. The "intensely autobiographical" works have been described as "poetic, nightmarish dreamscapes—campy giggles tinged with Gothic terror and necrophilia." "I always try to reveal something dark or hurt or wounded in myself," confesses Oliver, whose annual Halloween show at La Mama has become an All Hallows' Eve ritual for New York's morbid masses.

Asked how he found his home, which he moved into shortly after arriving in New York in 1979, Oliver weaves one of his typically outlandish, bizarre tales. "I walked by this house," he recalls, "and a gnarled old hand reached through these yellow venetian blinds and taped a sign to the window that read ROOM FOR RENT in oddly scrawled letters. I knocked on the door and an old man with a potbelly wearing nothing but a bath towel answered. He said that there was a room on the top floor. It was little but I took it immediately."

Born and raised in Savannah, Georgia (a town famous for its Southern Gothic mysterious ways), Oliver's eccentricities emerged at a young age. "My sister and I were very shy as children and had a strange, similar way of speaking," he recalls. "Mother was very shy and paranoid, she never cooked, and would make us go up to the windows of the drive-thru to order things because she didn't want to have any contact with anybody." It was an attendant at the local Dairy Queen who first grilled Oliver about his now innnnnfamousss accent. "The first time I ever heard of Transylvania was at the Brazier Burger," he remembers fondly. "The guys said, 'Where are you from? You sound like you're from Transylvania.' After a while I began to agree."

This East Village institution questions people's perceptions of his odd ways. "I've begun to get the impression that maybe I'm stranger than I think I am," he admits. "I never thought of myself as all that peculiar but in some ways I think that I am sort of a clown—and that makes me happy. I like the fact that people find me to be amuuuuuusing."

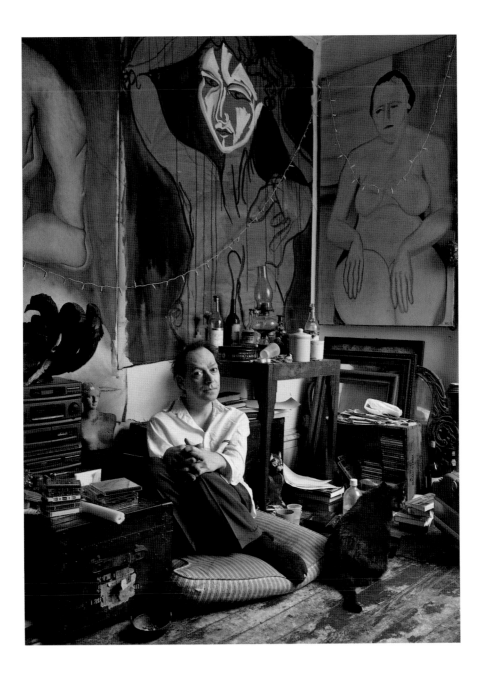

Rev. Betty Neal

Read through New York's tabloids and you would think that there is no love lost between the city's African-American community and the New York City Police Department. Reports of strained race relations and words of hate dominate the headlines. But spend an afternoon on 116th Street with the Rev. Betty Neal and you would wonder whether this is the same city that the papers write about. In a small nondescript room in the heart of Harlem, police officers, firefighters, and members of the African-American community pass the time gossiping together, eating together, and enjoying each other's company. Reverend Neal, an attractive, bright-eyed woman with a shock of white hair, is the hostess of these "love-ins." With them, she has realized a vision that she first had when she moved into drug-ridden Harlem almost twenty years ago.

Neal is the founder of Ministers of Harlem USA, an organization whose original purpose was to help improve relations between the Harlem community and New York's police and fire departments. Back in the early 1980s, Neal recognized that there was a complete lack of understanding in the Harlem community, so she made it her business to foster change. Neal began an awards program to honor New York's finest (she has already honored over five hundred people). She also began to throw block parties where police and firefighters would come out and talk with the community, teach children about safety and how to stay out of trouble. "I am most proud of my work in bringing the police and firefighters in a closer relationship with the people of Harlem," explains Neal. "When I first got here, firefighters would come put out a blaze, police would come and bust a drug dealer, and then they wouldn't be seen again until the next fire or drug bust. I put an end to that."

In spite of all this apparent goodness, the Reverend Betty engenders much controversy in her community—neighbors either love her or hate her. Many Harlem community leaders, including the better-known Rev. Al Sharpton, sharply disagree with her conciliatory tactics. And where the vast majority of African-American leaders roundly criticize the work of Mayor Giuliani, Reverend Neal has deep admiration for the man, calling him a friend. Recently, Reverend Neal generated headlines by reaching out to Justin Volpe, the ex-cop who is serving a thirty-year prison sentence for sodomizing Abner Louima. Much to the chagrin of many of her Harlem neighbors, Neal has counseled and supported Volpe and his parents, organizing reconciliation prayer meetings in Harlem for the Volpe family.

"I can't hate anybody because if I do, I'm not a Christian," reasons Neal, "I'm just living and doing the Christian work. On my epitaph I want it to say, 'May the work I do speak for me.' " As for the other leaders in the Harlem community who disparage her efforts: "We're all brothers working in the same vineyard—we're just taking different routes."

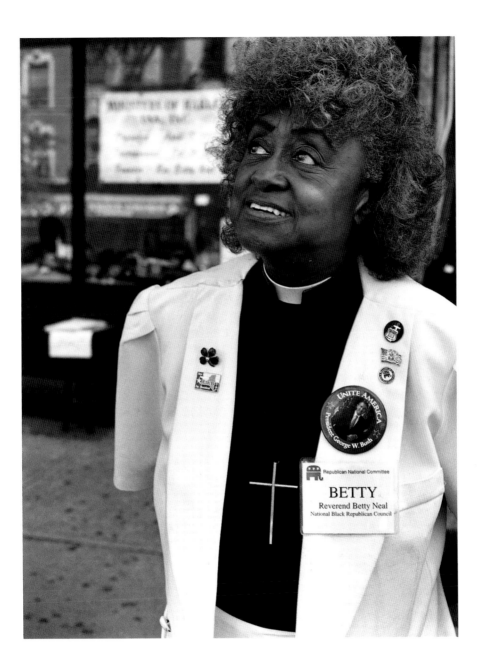

RICHARD JOHNSON

Did you know that ex-Senator Al D'Amato was canoodling with a buxom blonde at some Upper East Side restaurant? Did you hear that Monica Lewinsky ordered two servings of ravioli at dinner the other night? Did you see that Richard Gere got a ticket for urinating on the street? If you're asking yourself, "How in the world would I possibly know any of this?" then you surely don't read the *New York Post*'s Page Six, the city's ground zero for gossip. And Richard Johnson, Page Six's editor, is our resident town crier, dishing dirt on our celebrity and society crowd.

In a city where everyone talks about everyone else, this born and bred Manhattanite carries major clout. Johnson, who started his *Post* career on the city desk, has edited the most powerful page in New York since 1985. Every day, he and his staff can be found in the *Post*'s bustling newsroom working the phones and generating juice that's fit to print. "I get more calls and messages in a day than I could possibly handle," says Johnson, who blends right in with the beautiful people he covers. "The stories come from all over the place—publicists, other periodicals, cold calls from loyal readers, and stuff I just overhear at dinner parties."

This city of yentas is as addicted to Page Six as its morning cup of coffee. But if one traffics in the worlds of media, publishing, politics, or fashion, Page Six (which, ironically, no longer appears on page six) is not just fluff; it's required reading. The column gives those who keep tabs a one-page daily scorecard on what's hot, what's not, who's in, and who's out (and, of course, which billionaire is dating which supermodel). And though many deny it, most of the city's café society love to see their names in bold print. "I guess it's some sort of validation," explains Johnson.

Because Johnson and his crew are the best gossipmongers around, their stories often reverberate far beyond Page Six. Watch any of the evening entertainment television shows or national news broadcasts and you're bound to see a story that was first reported on Page Six. "I love breaking an important story and then hearing Don Imus talking about it the next day," exclaims Johnson. Even the venerable *New York Times* has picked up stories that Johnson first ran (this happened with a *Post* scoop on President Clinton's strained relationship with Jimmy Carter).

Since the pen is mightier than the sword, Johnson, not surprisingly, has made some enemies along the way. As for the celebrities he has angered (like Billy Baldwin and Mickey Rourke, with whom he has had well-publicized feuds), Johnson remains unfazed. "You've got to have a couple of enemies," he explains. "People judge you by who your friends are but they also judge you by who your enemies are. So you have to select your enemies just as carefully as you select your friends. And I'm very proud of my enemies—because they're all assholes."

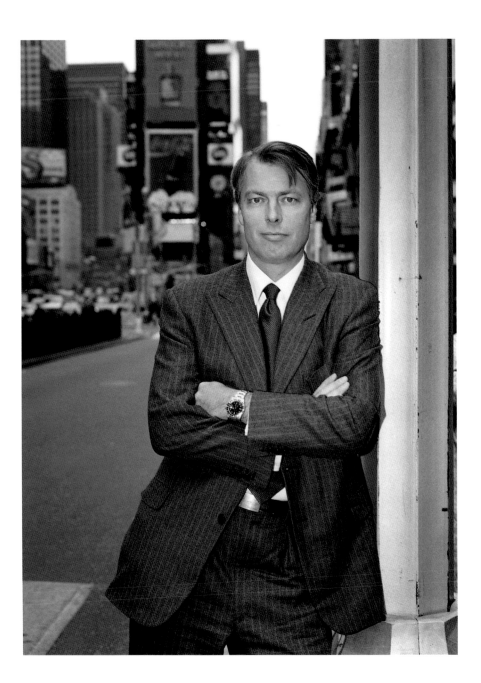

GEORGE PLIMPTON

Calling George Plimpton just a writer would be like calling Martha Stewart a gardener or Leonardo da Vinci a painter. Plimpton, a native New Yorker, has used this city as a launching pad to pursue his very own unique and fabulous life adventure. He is our resident Renaissance man: writer, editor, actor, bird-watcher, pianist, athlete, and . . . High Commissioner of Fireworks?

Born in New York City in 1927 to a well-to-do old-line family, Plimpton has led an enviable life. Educated at Harvard and Cambridge, he spent time in Paris before returning to Manhattan to pursue his myriad careers. Plimpton has written and edited almost thirty books, founded a revered literary journal, *The Paris Review*, and traveled the world writing innumerable articles on innumerable topics for innumerable magazines.

In the 1960s, he gained acclaim and popularity through his work in the field of participatory journalism. In this special brand of reporting, Plimpton didn't just write about his subject, he lived it. Whether sparring with world champion boxers, playing percussion for the Leonard Bernstein–led Philharmonic, or snapping photos as a *Playboy* centerfold photographer, Plimpton tackled his subjects head-on. Indeed, his football book, *Paper Lion*, is hailed as a classic of sports writing, detailing his experience as a rookie quarterback for the Detroit Lions.

For another story, Plimpton traveled to Jordan to document what it would be like to be in the film *Lawrence of Arabia*. Even though he cannot spot himself in the movie (he played a Bedouin in a large crowd scene), this experience resulted in a career of film cameos. Maybe it's his booming Brahmin voice or classic WASP looks, but for whatever reason, Plimpton has found his way into numerous Hollywood movies. "I guess I'm good luck," he explains. "Three of my films—*Lawrence of Arabia*, *Reds*, and *Good Will Hunting*—have gone on to win Academy Awards." What for some might be considered a celebrated movie career is a lark for Plimpton, just another set of life-enriching escapades.

Of all his amazing antics, arguably the oddest and certainly the most explosive is his role as the city's Fireworks Commissioner. The story of what this is all about and how it came to be is vintage Plimpton: "John Lindsay, the former mayor, asked me to take a cabinet position. Since I couldn't do it, he asked me, 'What would you like to be?' and I said, 'I would like to be your Fireworks Commissioner.' He commissioned me such, and though there is no official thing, I keep hanging on to my position. You are supposed to resign when there is a change in administrations, but I haven't, and nobody's forced me to—I think I'd confuse them too much if I did resign. But most of the mayors have known that I am their Fireworks Commissioner. I've been going out on the barges to oversee things and I'm a licensed pyro-technician."

A four-story town house overlooking the East River acts as Plimpton's hub, serving as both his home (which he shares with his second wife and twin girls) and headquarters to *The Paris Review*. Though Plimpton is as worldly as it gets, his odysseys always bring him back home to the city around which his desirable life revolves.

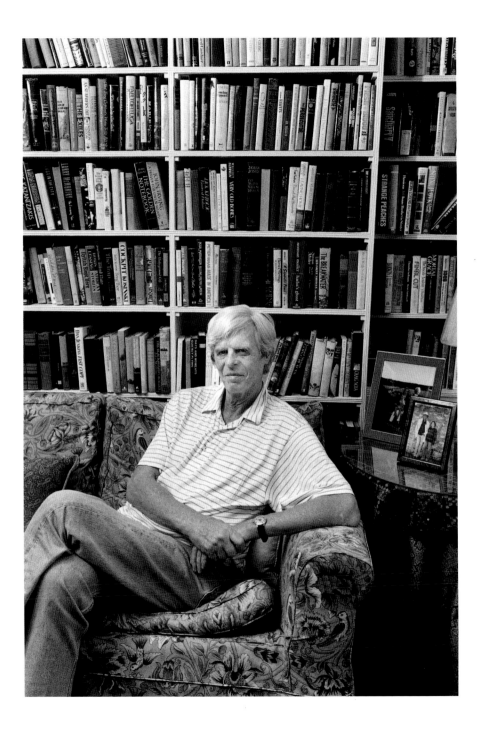

Dr. Zizmor

Acne! Bumps! Boils! Growths! Ask any New York subway rider how to rid yourself of these unfortunate maladies and they'll most certainly respond with a smile, "Go and see Dr. Z!" Dermatologist Dr. Jonathan Zizmor is undoubtedly our city's most recognizable physician. Like pimples dotting an adolescent's face, Dr. Z and his colorful ads are ubiquitous.

It all started about twenty years ago when Zizmor decided to jump-start his practice by taking out an ad in the Yellow Pages. "People were shocked," Zizmor recalls. "At the time, it was completely unheard of for doctors to advertise." Though Zizmor was literally the only doctor in the book, it brought patients in the door. Building on this successful experiment, Zizmor decided to descend into the world of subway advertising. "Then people thought I was completely crazy!" he exclaims.

Maybe a little crazy, but also very smart. His business grew exponentially, and Zizmor now has one of the most successful and unique dermatology practices in the city. "People come in here thinking that I don't really exist," he explains. "They suspect it's going to be some huge group of doctors practicing under the Dr. Zizmor name, when in fact, it's only me." Dr. Z personally treats every patient that walks through his doors.

Aside from his personal touch, Dr. Z attributes much of his success to the unconventional style of his ads. Filled with exclamatory phrases (Acid Peels! Mole Removal!), family vacation photos, bold rainbows and decorative snowflakes, they are hardly subtle. "I design them all myself," he says. "My test is quite simple: I'll ask my friends, 'Do you like this ad?' and if they say, 'That is the worst ad I've ever seen,' then I'll definitely run it." (His less frequent but equally quirky low-budget cable TV spots are also legendary, with clear-skinned patients gleefully shouting, "Thank you, Dr. Zizmor!")

While a handful of his "fancier" clients left Dr. Z's station when the subway crowd came rumbling in, his practice still encompasses a wide cross section of New Yorkers. "Some of the city's highest profile socialites are my patients, and so are their maids," he boasts. "Most doctors only want to treat Nelson Rockefeller; I'd rather treat the masses." He also mentions one of his more intriguing groups of clients: men who cheat on their wives. "They're usually scared that they've caught some terrible venereal disease but are afraid to go to their family doctor," explains Dr. Z. "It's mostly paranoia—there's usually nothing wrong with them."

Thousands of clear complexions later, Dr. Z revels in his fame and success. "The reservoir of goodwill I have acquired is remarkable, and from people I've never even dealt with," he says. "I think it's because I've become old and familiar." Surely, Dr. Z's the only dermatologist regularly stopped on the street by autograph seekers. Even a New York Aptitude Test published by the venerable New Yorker asked its readers, "Who is Dr. Zizmor?" But, as is often the case, there is a downside to his success. "A lot of other doctors hate me," Zizmor laments. "If they have a bad work day they think it's because I have all the customers sitting here." Or maybe—and listen up all you other doctors—they're sitting on the subway!

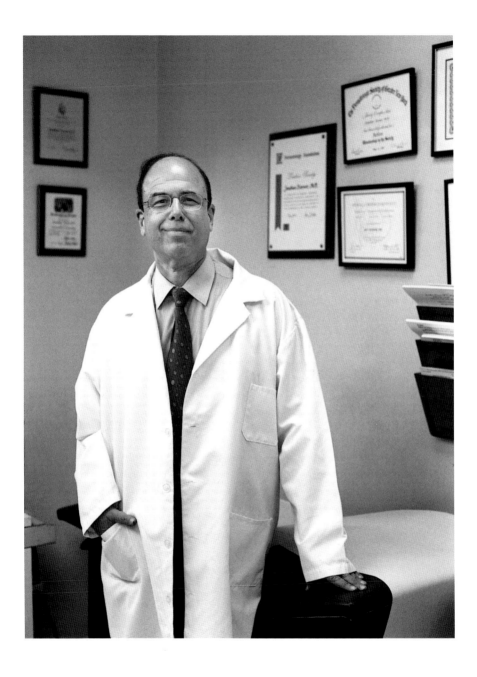

HENRY HOPE REED

New York's architecture is nearly as diverse as its people, with prewar, postwar, and postmodern buildings often sharing the same city block. While many New Yorkers revel in this diversity, a lifelong New Yorker named Henry Hope Reed winces at it all. If he had his way, everything but the classical would be erased from the city's map. Speak with Reed about great public works like Grand Central Terminal and the New York Public Library, and you will hear passion and enthusiasm in his dignified voice. But ask him about some of the more recent and notable architectural efforts, and his mood turns sour. Museum of Modern Art? "Ridiculous." The United Nations? "Mercilessly and savagely clean." The acclaimed Seagram Building? "A grotesque joke."

Reed is our city's chief champion of classical architecture. With his rumpled bearing and tweed jacket and cap, Reed looks the part of a New England boarding school professor, but he is a New Yorker through and through. Born in 1915 in the West Village and raised on the Upper East Side, Reed attended a New Hampshire boarding school, collected a degree from Harvard University, and studied in Europe before settling back down in the Big Apple for good.

Since the 1950s, Reed has made his mark on this city through a single-minded obsession: tirelessly extolling the virtues of classical design while simultaneously trashing modern architecture. Way back in 1956, Reed, bored with committee meetings at the Municipal Arts Society, decided to liven things up a bit by sponsoring walking tours throughout the city. Whether it was a trip across the Manhattan and Brooklyn Bridges, a stroll through Central Park, or a tour of Upper East Side brownstones, Reed—who, as one colleague put it, "knows everything about everything"—gave his flock of walkers his two cents on our city's architectural landscape.

With the walking tours a big success, Reed continued to spread his gospel through exhibitions, classes, and newspaper articles. In 1968, he formalized his one-man crusade, founding Classical America, an organization that encourages the classical tradition in art and architecture and sponsors a vigorous program of lectures, classes, and publications.

For Reed, majestic columns, grand domes, and ornate murals are forever in; garish glass, unsightly steel, and boxy designs are out. When asked about the continued proliferation of modern architecture, Reed rants on, utterly convinced that someday New York will rid itself of all the "eyesores" that blight its landscape. "It's a farce," he exclaims. "The thing that's terrifying is that these horrors are going on and they haven't stopped. These trashy, giant glass boxes are junk. They are, quite simply, the glorification of junk and will end up in somebody's basement someday." Spoken like a classic New Yorker!

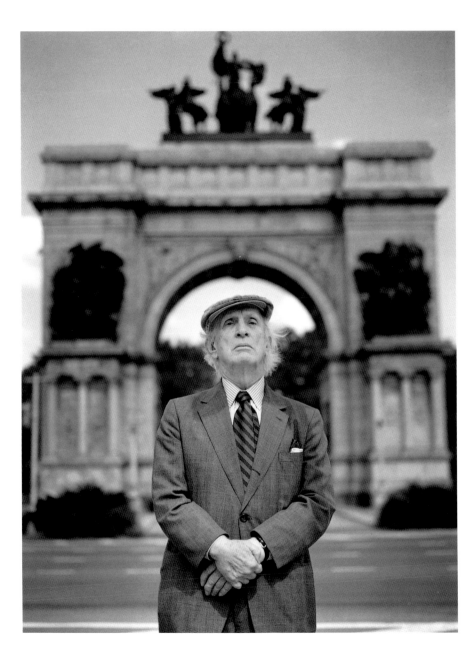

LAUREN EZERSKY

New York, Paris, and Milan. Three cities inextricably linked by the trendy threads of fashion. But which one is the true capital of the fashion world? Well, Milan's got the legendary houses of Armani, Versace, and Prada. Chanel, Hermès, and Galliano certainly make Paris a formidable foe. But when all is said and done, neither holds a candle to New York, because we've got Ralph Lauren, Donna Karan, and . . . Lauren Ezersky!

With an insatiable passion for fashion, a priceless New York accent (think Fran Drescher), and a whole lot of chutzpah, Lauren Ezersky has become a staple in this city's rarefied air of high design. Ezersky is the host of cable television's *Behind the Velvet Ropes* and fashion columnist for tragically hip *Paper* magazine, where she interviews the industry's A-list and dishes juicy gossip on the catwalk crowd. In a city of clotheshorses, Ezersky is a breed all her own. How did this Yonkers girl who always got in trouble for wearing too-short skirts become a Manhattan fashion plate?

By appearing on *The Oprah Winfrey Show*, of course. Before finding herself in front of the camera, Ezersky had been pursuing her garment center dreams, working as a saleswoman, a buyer, and even a personal shopper. When a friend put her in touch with an *Oprah* producer looking for a "shopaholic," Ezersky seized the opportunity, appearing on the show telling tales of Bloomingdale's binges and Saks attacks. As luck would have it, the original host of *Behind the Velvet Ropes* caught the piece and invited Ezersky to appear on his show.

"On my very first *Velvet Ropes* appearance, the fashion critic had a hissy fit and stormed off the set," remembers Ezersky. "So I took over." Five years later, Ezersky's half-hour program features her irreverent interviews with the world's hottest designers and her behind-the-scenes look at the voguish shows and parties of the fashion world. The show has gained in popularity, moving from public access cable to the Style Network, where it is now broadcast all over the world.

Asked about the alleged "shopaholism" that initially thrust her before the television camera, Ezersky denies that she suffers from the disease. "I'm not a real shopaholic," she protests. "At least I can pay my rent and buy snacks for my chihuahuas [Tallulah and Gomez]. But of course, any extra money that I have I do spend on clothes, jewelry, bags, and belts." A peek in her closet, crammed with costly couture, confirms this.

A large part of Ezersky's appeal is her dare-to-be-different approach to fashion. With her striking good looks, her trademark streak of white hair, and her outrageous outfits (how about a top hat with a tutu?), Ezersky always makes a bold statement. "Fashion is fun and that's why I love it," she exclaims. "I don't want to look like the girl next door. I'm not the girl next door. And why should I look like that? Why should I look like everybody else? You have to make your own way in this world and be yourself."

OPERA MAN

You don't need to buy orchestra seats at Carnegie Hall to hear the world's great music. For the past fifteen years, Larry Danzinger has been belting out arias on 57th Street between Seventh Avenue and Broadway. Did he pick this locale because of its proximity to New York's great halls of music? "No," responds Larry. "I just picked it, and that's where I've been standing all of these years."

Larry's dramatic flair causes pedestrian traffic jams on one of the world's most well-traveled streets. His often-quivering voice covers the vocal spectrum, from a high pitch to a low rumble. Larry's facial contortions are downright scary. His eyes bulge and his face fills with anguish. In a single song, he'll pound his chest, crouch on the ground, stand on his toes, and reach his arms toward the sky. It's an unforgettable performance.

Born in Brooklyn in 1944, Danzinger realized he was born to sing. He took his first voice lesson at sixteen, and was soon tossed out of school for crooning during gym class. He enrolled in night school to complete his education, then took on odd jobs as a messenger, a Good Humor man, and an usher at the famed Apollo Theater. None satisfied his passion for opera. "Singing is my lifeblood," he explains.

In recent years, Opera Man has gone national. *On Saturday Night Live's Weekend Update*, Adam Sandler played an Opera Man character whose act bore a striking resemblance to Danzinger. That showcase, in turn, resulted in Danziger appearing on *Late Night with Conan O'Brien*.

Still, Danzinger's real dream is to star in a film about the opera singer Mario Lanza and to sing opera professionally. But for now, you'll find him stretching his vocal chords on 57th Street, satisfied being one of New York's most well known street entertainers. Hey, it's not over until the fat lady takes over his sidewalk.

BLADE RUNNER

He calls his right skate Yin, his left skate Yang. He is Zee Vincent Brown, a.k.a. Zee Blade Runner, high priest of the Central Park in-line crowd. Whether he's a spinning mass of energy and dreadlocks gliding around the "roller-dance floor" in the center of the park or demonstrating his Tai Chi routine in a meditative trance, you can't miss Zee.

In a park full of eccentrics, Zee stands tall. Often decked out in a homemade spandex bodysuit and tank top emblazoned with his name, he arrives on a self-designed bicycle, ornamented with tassels and horns. At the roller-dance area near the Mall, he buckles up his blades and launches into his routines, a spinning mass of dreadlocks and slippery moves. He loves the attention, and gets plenty of it.

The funny thing is, if you saw Zee walking down the street, you wouldn't look twice. You'd see a conservatively dressed guy who looks like a Ph.D. candidate—which is exactly what he is. The thirtysomething NYC native is an NYU graduate and a doctoral candidate in social science at City College. Only recently he figured out a way to combine his pursuits: helping to pay for his education by selling "The Flowmotion Wheelers and Zone Flow," the world's first roller-cise home fitness video, available wherever you see him blading.

Like so many New Yorkers, Zee uses Central Park as a refuge from the everyday grind. Once winter turns to spring and blading weather hits the city, Zee's Rollerblading half of his split personality predominates. "I see Rollerblading and this beautiful park as a place to express myself," Brown says of his alter ego.

AL GOLDSTEIN

There are two sides to Al Goldstein, New York City's most famous pornographer. One minute, he is all charm, speaking eloquently and insightfully on numerous topics. The next, he's in a fiery rage, ranting and attacking everything from marriage to religion. But throughout Al's wild personality swings, one thing remains constant: his preoccupation with women.

Back in 1968, this obsession led Goldstein to start *Screw* magazine, which has now graced New York newsstands for over three decades. As a hormone-crazed young man, Goldstein found 1960s pornography artificially romantic and sanitized; with *Screw*, he sought to create something more realistic, edgier, and political. *Screw* is the anti-*Playboy*: nothing sleek, nothing glossy, and no airbrushed playmates, just raw pornography and vitriolic rants on society and politics (he recently, for instance, compared Rudolph Giuliani to Hitler).

"It's the kind of newspaper I would've bought myself," explains Goldstein, whose advertisers are almost exclusively escort services and the like. With the success of *Screw*, Goldstein branched out into other media; his television show, *Blue*, is equally crude and equally successful. *Blue* is New York's longest running adult entertainment program.

Goldstein's formula is simple: Sex sells, and he's made the most of this axiom. Now, with a fine Cuban cigar a constant appendage to his arm, Goldstein lives the high life, complete with four homes, sports cars, the finest restaurants, exotic travel, girlfriends, and prostitutes. That's right, girlfriends *and* prostitutes.

Before becoming New York's pornographer-in-chief, Goldstein lived through several more pedestrian careers. He drove a cab, sold insurance, and wrote for the tabloids before finding his calling as our king of smut. "I can identify with my readers," he explains.

His current hedonist lifestyle has its hazards. Goldstein's been divorced four times and at five foot eight and hovering near three hundred pounds, he's a self-described "obsessive eater." He also spends much of his free time mired in the courts. Whether it's his nineteen arrests for *Screw*'s violation of the obscenity laws or the dozen or so times that he's been sued for libel, Goldstein relishes the courtroom (his office television is locked on Court TV) and vigorously fights to protect his freedom of speech.

"Too much of a good thing is wonderful," exclaims Goldstein. "Too much sex, too much food—I want everything, every experience. Every woman. Every cigar. I'm an addict. If I was a drug user, I'd blow my nose off my face."

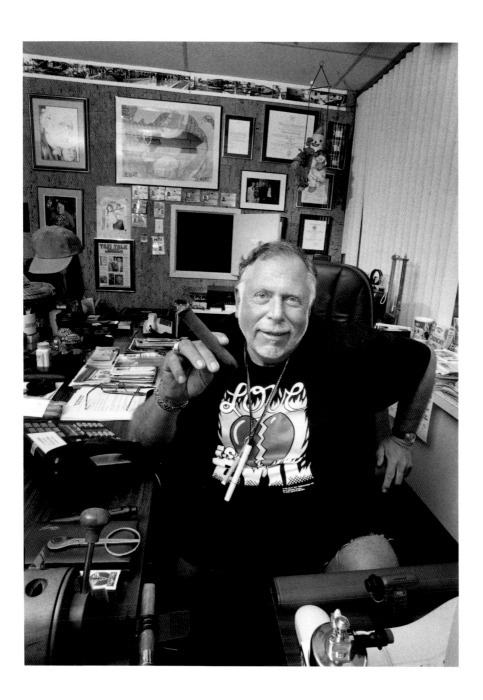

THE EGG CAKE LADY

Every morning at the crack of dawn, a petite woman named Cecilia Tam lugs two plastic jugs of viscous, pale yellow liquid through the streets of Chinatown. People gawk at her as if she's a queen carrying the crown jewels. Everyone asks themselves, just what is in that batter? Mrs. Tam refuses to say, closely guarding the ingredients the way Coca-Cola guards its secret recipe. Whatever the contents, New Yorkers line up in droves for her famous egg cakes.

The Tam egg cake dynasty began in Hong Kong, where Tam's father raised eight children on the proceeds of the pastry. The Tams moved to New York in the 1970s, and in 1982, struggling and looking to make ends meet, Mrs. Tam took her father's recipe and set up shop in the heart of Chinatown. "I had to do something," she explains, "and anything was better than welfare." Well, the rest is New York culinary history. Despite the bargain price (one dollar for a bag of fifteen cakes), Mrs. Tam has managed to put two children through college. Any way you do the math, that's a whole lot of cakes!

The "Egg Cake Lady" serves these delectable delights from an inconspicuous, modest red shack at the corner of Mott and Mosco Streets. There are no flashy signs or fancy menus, just a round aluminum tray and a couple of stove-top burners. Though the Chinatown neighborhood is dotted with egg cake stands, Mrs. Tam has cornered the market. Mrs. Tam's devotees have been known to travel from all points of the city for these scrumptious golden nuggets. "They're sublime, just breathtaking," was all one happy customer could say after inhaling a bag of cakes.

But don't dawdle in getting there. Unfortunately for her fans, Mrs. Tam's special concoction never lasts long enough to fulfill the daily demand. Whenever she runs out of batter, no matter what time of day, she closes up shop and vanishes into the streets, empty jugs in hand.

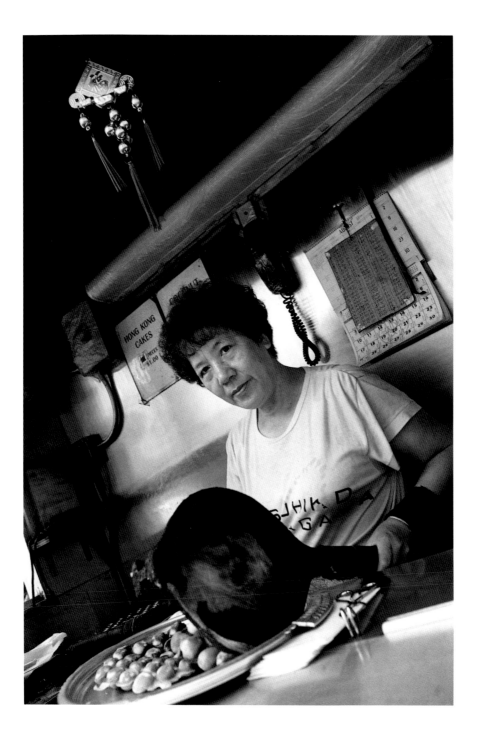

POET-O

In the grand tradition of legendary New York bohemian poets like Walt Whitman and Allen Ginsberg, Isidore Block—more commonly know as Poet-O—roams the city creating and reciting poetry for those who will listen. And just as Brooklyn was to Whitman and Greenwich Village was to Ginsberg, Central Park is Poet-O's home and muse. For decades, Poet-O has been the park's poet laureate, the bell-ringing bard of Manhattan's green oasis.

Poet-O spends his days composing poetry for passersby on whatever writing surface is available: envelopes, shopping bags, menus, index cards, and wrapping paper. For a small fee, of course. And don't expect "Roses are red, violets are blue"–type nursery rhymes. With an impressive vocabulary and imagery, Poet-O's verse is heavy stuff, addressing personal themes such as homelessness and prison. Usually, however, there's a little levity mixed in. "Poet O dreads to tread these weary streets alone without a place to rest my weary hemorrhoids." (Helpful hint: for a premium, Poet-O delivers X-rated rhymes!)

"Ring a bell, make a wish," cries Poet-O, calling out his other vocation. Slightly less artistic (and certainly more capitalistic) than his poetry, Poet-O also makes people's wishes come true with his unicorn-shaped brass bell. Park-goers bring the bell to their ear, listen to the echo, and make a wish. (Oh yeah, for your wish to come true, it helps to put money in the basket.) "Whatever is put in," he promises, "will come back a hundredfold." Poet-O lists Barbra Streisand, Yoko Ono, and Woody Allen as New York notables who have rung the bell.

According to Poet-O, he was born in 1920 in Central Park's Sheep Meadow. This could explain his deep emotional connection to the park and the people that inhabit it. "I know every corner of this park," Poet-O whispers. "I know all its characters and hiding places. I know its secrets!" Occasionally, he still sleeps in the park to "keep in touch." But most nights, Poet-O rests his weary hemorrhoids at Woodstock, a Times Square senior citizens' home.

His life hasn't exactly been a walk in the park. Abandoned by his mother and father at a young age, Isidore spent his formative years in and out of reformatories, prisons, and mental institutions. He discovered poetry while serving time at an upstate juvenile detention center after being caught with marijuana in Times Square. (His pseudonym comes from Pauline Reage's erotic novel *The Story of O*, which he found in the detention center's library.) Poet-O's fellow delinquents were so taken with his poetry that he began to take his writing seriously.

But he never takes himself too seriously. When asked why he has yet to become famous (though European tourists regularly seek him out), he complains that "no one will give me a chance because I look too much like Ed Koch!" Now that's poetry!

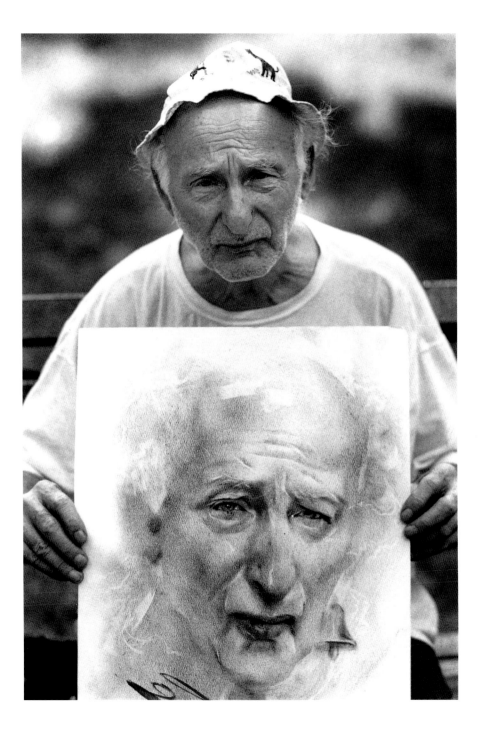

BROOKLYN DODGERS
SYM-PHONY BAND

It is impossible to convey to today's young baseball fan the passions that once existed over Brooklyn's beloved Dodgers. Where hallowed Ebbets Field once was, an unsightly apartment building now sits. And the hearts and souls of that team—Robinson, Reese, and Campanella—have all passed on. But wait! There's hope! The legend lives! Playing live on a street corner near you is the beloved, the incomparable, the tone-deaf Brooklyn Dodgers Sym-Phony Band. Bring your grandson down to listen to this quartet and he'll not only get a sense for the excitement and love generated by the Dodgers, he'll also get, well, a big fat headache.

In 1936, five guys, on their way home from a musical picnic in the park, decided to take in a ball game. They purchased tickets but were not allowed inside with their instruments. So three of them entered the ballpark while one stayed back. Once inside, they dropped a piece of twine over the fence and pulled each instrument up one by one. They soon blared away to a delighted crowd. The ticket takers were fuming, but the Dodgers' legendary owner Branch Rickey—always the crowd pleaser—let them play. Indeed, Rickey was so impressed that he gave them box seats and invited them to every game.

Soon enough, they were given an appropriately demeaning name—the Brooklyn Dodgers Sym-Phony Band—and became Ebbets Field fixtures. Terrible instrumentalists and worse vocalists, their brutal performances were part of their charm. And they didn't just play—they led the peanut gallery, heckling the Dodgers opponents and riding the umps at every chance. If there was a questionable call at the plate, the band blared "Three Blind Mice." If an opponent went to the water fountain, they'd do their best rendition of "How Dry I Am."

In 1955, when the Dodgers tragically moved to L.A., the Sym-Phonies stayed behind, fading deep into the recesses of N.Y. sports history. It wasn't until almost fifty years after they mangled their last tune that John Campi, a *Daily News* executive, came along and exhumed them. When famed Yankee broadcaster Mel Allen and renowned national anthem soloist Robert Merrill kicked off the *News*-sponsored NYC Stickball Tournament, Campi thought to himself, "If we only had the Sym-Phonies."

As he soon found out, be careful what you ask for. The *News* went to Williamsburg, Brooklyn, and tracked down the only two living original band members: Lou Dallojacono and Jo Jo Diello. Both, well into their eighties, were thrilled with the idea of a comeback, so they drafted three other guys "equally as untalented" and put the band back together. Classic old-timers with thick Brooklyn accents, the band still plays with the same zeal as they did from their Ebbets Field box. Lou still dances around like a young Mick Jagger (his repertoire even includes jumping splits), while Jo Jo, barely four feet tall, plants his nearly deaf ear in the trombone so he can rhythmically bang his cymbals.

Campi explains their appeal: "The Dodgers were a cult unlike anything we have today and the band was very much a part of that cult. When people see them now, they are brought back to a special time and place in New York. Even if they have to hold their ears!"

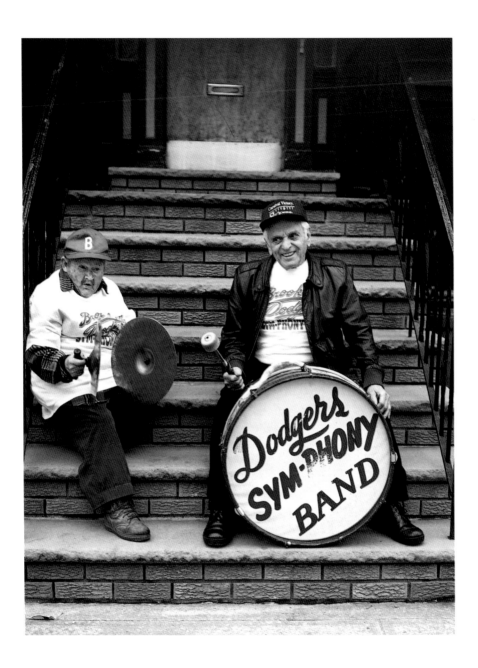

Rev. Al Sharpton

The Rev. Al Sharpton is one of the city's most powerful politicians. Yet he's never been elected to office. He's a civil rights leader in the tradition of Martin Luther King, Jr. Yet he preaches at a time when the movement has, according to some, all but disappeared. Sharpton is a bundle of contradictions, packaged tightly in a three-piece suit and a shock of wild, graying hair. But one thing's for sure—no matter what contradiction he is working through at any given moment, there is bound to be a slew of reporters and television cameras there to document it. The New York media follows Sharpton practically everywhere but the bathroom.

"The average New Yorker doesn't understand all the media connections and infrastructure that I have," says the city's premiere pressmonger. While he's probably right, what's easy to understand is how Sharpton has become not only a New York political force but also a national figure to reckon with. After impressive though unsuccessful campaigns for the U.S. Senate in 1992 and 1994 and a failed mayoral bid in 1997 (in which he received 32 percent of the Democratic primary vote), Sharpton is seen as holding the key to New York's important black voting bloc. When national politicians seek the favor of the city's black constituency, they now all come a'knockin' on Al's door. Bill Bradley, Hillary Clinton, and Al Gore each made the requisite pilgrimage to Sharpton's hectic Harlem office during their 2000 campaigns.

Yet Sharpton's public image comes more from his involvement in controversial civil rights court cases than political campaigns. Years ago, he made national headlines by standing up for a young black woman named Tawana Brawley, who claimed she was raped by a group of white men. Though Brawley was ultimately determined to have fabricated the story, he has never backed down from his position. "I think that we owe it to our people to take the risk of standing up for them," Sharpton explains. "I'd rather stand up for her and be right about standing up—if she were wrong, let her be wrong."

Post-Brawley, Sharpton immersed himself in the infamous police brutality cases of Abner Louima and the late Amadou Diallo. Recently, he was arrested on the Puerto Rican island of Vieques for leading protests and demonstrations that interfered with U.S. military bombing practices. Even Sharpton opponents have described his campaign for justice in these controversies as powerful, unflagging, and effective.

Much of Sharpton's work doesn't make tabloid headlines. Still motivated by his civil rights roots, Sharpton can be heard preaching every Sunday morning at Harlem's National Action Network on 124th Street. "The media makes me look like I'm just agitating and making trouble rather than responding to real social ills," he says. "But this is the most educated generation of blacks in our nation's history, and we have less to show for it than we have ever had."

It's sermons like this one that remind both his followers and his critics that Sharpton's real focus is not on the cameras, but on the people. As long as race relations remain an issue in New York, the Rev. Al Sharpton will be front and center, zealously defending the rights of the city's black community.

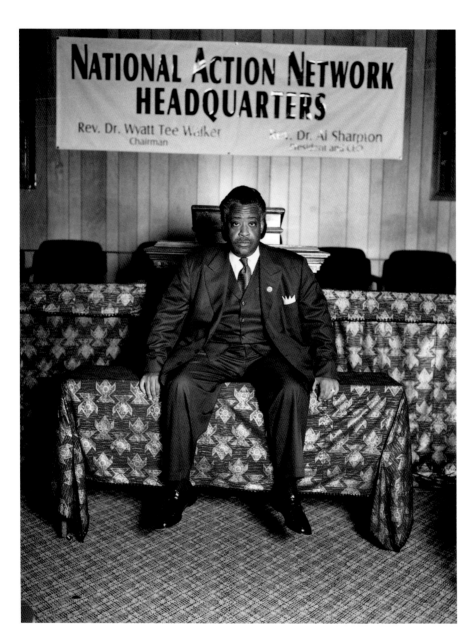

PATRICK McMULLAN

Imagine being invited to so many parties, so many cool parties, that you have to hire people to go in your place. That's the predicament of Patrick McMullan, New York's most sought after event photographer. In a city whose social calendar is 24/7, McMullan and his merry band of society snappers work tirelessly to capture on camera the hottest soirées and shindigs in town.

The secret to McMullan's success is that he plays as hard as he works. Apart from the photographic appendages attached to his body, McMullan is just another guest at the party. Watch McMullan work a room and you'll quickly see that he's not just telling people to smile and say cheese. "When I go to an event, I like to be a good guest first," says the gregarious native New Yorker. "Just like at any party, I'll eat, drink [no liquor], and move around the room introducing people I think would have an interest in each other. While taking pictures I try to keep it short and simple."

McMullan wasn't always the nonstop party boy he is today. After graduating from NYU, McMullan worked as a photographer's assistant before being diagnosed with cancer at the age of twenty-four. "I was sick for two years and the experience changed me a lot," he says soberly. "When I got better I wanted to go to everything, do everything, and be everywhere. So I did it with my photography." What began as a small gig covering nightclubs for *Details* magazine became a business with about twenty employees, a sprawling downtown office, and more job requests than he can possibly handle.

Of course, part of McMullan's popularity comes from his fulfilling a very important role for the rich, the famous, and the wannabes—he gets their names and faces in print. With regular photography "columns" in such magazines as *New York*, *Interview*, *Elle*, *Vanity Fair*, *Gotham*, *Quest*, *Manhattan File*, *Allure*, and *Hamptons*, McMullan's Nikon wields considerable power. As gossip columnist Michael Musto explains, "If Patrick doesn't take your picture, you're no one. If he doesn't say hi, you don't exist."

For this reason, McMullan's office is flooded with invitations to affairs across the city. To avoid making his absence a condemnation of a crowd, McMullan has several shutterbugs on staff covering events he can't make. "Everything that my employees shoot gets published under my name," he explains. "I've become a brand name." McMullan himself shoots an average of twelve parties a week and goes to bed each night at around five in the morning.

After twenty-five years of nonstop schmoozing and snapping, McMullan shows no signs of slowing down. In addition to his myriad magazine work, he's written two books and has opened a downtown studio. Like most people with a passion for what they do, McMullan doesn't think of his job as work. "For me, work and pleasure are a complete mix," he says. "Most of my friends are intertwined with my job. And I never get sick of a good party."

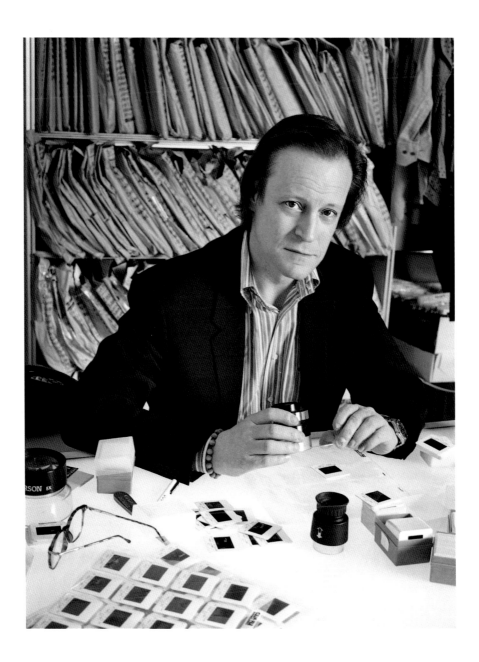

ADAM PURPLE

Back in the mid-1970s, an urban eccentric named Adam Purple (born David Wilkie), built the Garden of Eden on Manhattan's Lower East Side. An oasis of agriculture amidst a sea of bricks and steel, the garden was a stunning design of plants and flowers, brilliantly organized in concentric circles around a central Ying-Yang symbol. Purple had miraculously transformed five abandoned city lots into a wonderland of raspberry bushes and roses. Dressed entirely in purple, he would bicycle up to Central Park to collect horse manure and then ride back downtown with fertilizer in tow.

It was an astonishing creation. Tourists from around the world descended upon the garden, *National Geographic* did a spread on it, the neighborhood began to revitalize around it, and then New York City bulldozed it. On January 8, 1986, city officials and real estate developers teamed up to destroy his beloved work of art. Though it was just one of several crusades that Purple would wage against city bureaucracy, it was a defining moment of loss. A big piece of Purple died with the garden, and he stopped wearing the color that inspired his nickname.

But the diminutive man with a thick gray beard and boundless energy has remained a freethinking iconoclast long after hippy culture went out of style. Purple, until recently, waged yet another fight of his life, taking on the role of New York's celebrity squatter. With his garden destroyed, he steadfastly remained as the last tenant at 184 Forsyth Street, the abandoned city-owned building next door. For eighteen years, Purple lived an astoundingly ascetic life with no heat, no electricity, and no plumbing. He spent his days scavenging for wood (a wood-burning stove cooked his only food, a tofu-based vegetarian stew), collecting cans (an income of $2,000 a year from recycling sustained him), and tending to the dilapidated building. Despite his capital improvements, the city finally forced him out, claiming thousands of dollars in back rent. In 1999, they tore down the building, erecting characterless low-rise apartment buildings in its place.

These days, Purple, now an Upper West Sider with electricity and a "flush toilet," spreads his freethinking messages through the printed word. A voracious reader and writer, Purple is the author of the one-inch-by-one-inch *Zentences!* (on file in the New York Public Library's rare book collection), a nonlinear series of hilarious, hippieish one-liners. And even in his seventies, Purple is keeping up with the times, posting a cyber version of *Zentences!* on his very own website.

If you think Purple's gone soft and given up his radical ways, think again. Though he's lost a few battles, he continues to wage a war. These days, he's aiming high, calling for a "world general strike against global capitalism any and every next January 2." Long live Adam Purple!

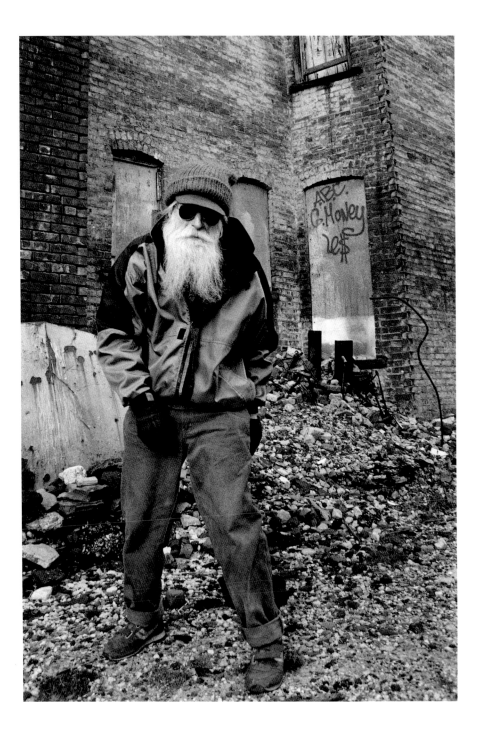

ZOE KOPLOWITZ

On one Sunday each fall, some world-class athlete finishes first in the New York City Marathon. And on one Monday each fall, another world-class athlete finishes last. Zoe Koplowitz, New York's slowest marathoner, takes roughly thirty heart-wrenching hours to complete this glorious twenty-six-mile journey. Hampered by multiple sclerosis and diabetes but armed with a whole lot of courage, Koplowitz has inspired people all over the world, well beyond the five boroughs that she traverses each fall.

Felled by MS in 1979, Koplowitz defied her debilitating disease and continued to lead a successful, vigorous life. A fiercely independent lifelong New Yorker, she supported herself by starting her own business, Smart Moves Trucking. Physically, though, Koplowitz had let herself go—by 1987, she was sixty pounds overweight, and getting around became increasingly difficult. Because of her debilitating disease, she had resigned herself to a sedentary existence. Then came a turning point.

"I choked on a vitamin C pill," Koplowitz says, recognizing the irony of it all. "Thankfully, my business partner saved my life using the Heimlich maneuver." Angry that a little pill almost killed her, Koplowitz says that the episode led to a reexamination of her life and a decision "to do the most outrageous thing I could imagine." What better way to triumph over a disabling disease than to conquer an event that symbolizes the strength of the human spirit, endurance, and willpower?

The Achilles Track Club, an organization for handicapped runners, helped Koplowitz train ("when I started I couldn't go four blocks without huffing and puffing") and provided her with a volunteer runner to accompany her during the race. In addition to Achilles, the Guardian Angels—the citizens' volunteer group that patrols New York City—also join her journey, guiding and guarding her through the city streets. "I am a team event," explains Koplowitz, who runs with her crutches. "Without my friends, I would never be able to do this."

Her first year running, Zoe and her Achilles contingent crossed the finish line in the dead of night, with no banners, time clock, or fans around. Today, Koplowitz's efforts generate national publicity; she is now met at the finish line by scores of fans and paparazzi. She has completed the last thirteen New York marathons (not to mention finishing London and Boston) and proudly revels in race day. People all over the city come out specifically to cheer her on. There is the group that gathers on Bedford Avenue each year, holding up ZOE signs and shouting encouragement. There are the neighborhood gangs in the Bronx who escort her until they reach the end of their turf and then hand her off to the next gang. "I've seen kids grow up, people get married, and have watched the elderly die—I've made lifelong friends along the marathon route," marvels Koplowitz.

For Koplowitz, however, all the hoopla that surrounds her efforts is of no moment. It's about the journey. As the poster of a faceless runner that is taped above her bed reads: "The race belongs not only to the swift and strong—but to those who keep on running."

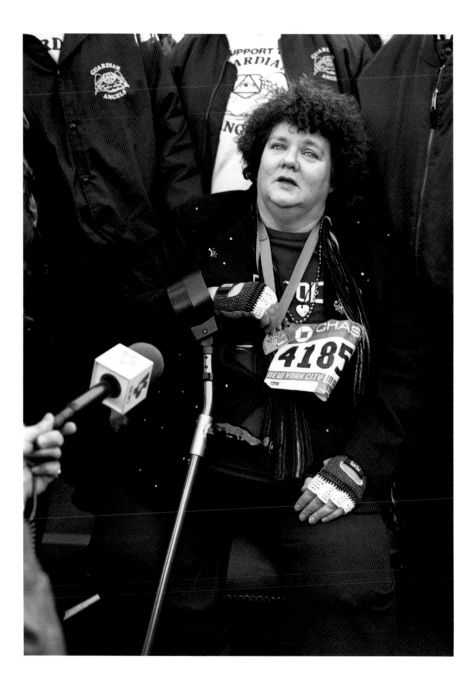

JOHN McENROE

In 1979, a twenty-year-old tennis genius named John McEnroe won the U.S. Open right in his own backyard, capturing his first grand slam at Flushing Meadows, just a ten-minute drive from his Douglaston home. With a combination of brilliance and brashness that turned the traditional, staid tennis world on its ear, Johnny Mac personified the city from which he came.

First, there was the brilliance. His game was unorthodox, possessing a deft touch, uncanny court sense, and legendary hands. McEnroe displayed a God-given talent that transcended his sport. This King of Queens would go on to become one of the greatest tennis players in history, winning four Opens, three Wimbledons, and attaining the world's number one ranking four years running.

Then, there was the brashness. If his talent transcended his sport, his infamous on-court temper often transcended the talent. To this day, he's not quite sure where the tantrums came from. "Once I got a reaction from the crowd, I fed off that reaction, which created its own sort of dynamic," explains McEnroe. "I didn't necessarily think what I was doing was right, but I was just standing up for myself. To sit back and not say anything would have been just as wrong."

Although his professional touring days ended in 1992, Johnny Mac stays close to the action. He's not only a highly respected tennis commentator on television, but he's also the top-ranked player on the senior circuit. "It's hard to get the competition out of your blood," he admits. "And it's a great way to make a living and stay in good physical condition." But even though McEnroe has mellowed with age, the fans still expect fireworks. "I used to get fined all the time for misbehaving," he jokes. "Now I get fined if I *don't* misbehave."

Today, living near Central Park with his wife, rocker Patty Smyth, and their six children (three are from his first marriage to actress Tatum O'Neal), McEnroe works at keeping his life in balance. "There is a side of my brain that is very sports-oriented and competitive, but there is another side that is very cerebral," he says. So when not being Mr. Mom, you'll often find him at his SoHo art gallery. Long a fan and collector of twentieth-century American works, McEnroe opened up a downtown space where he keeps an office and sees clients by appointment. In free moments, he blows off steam by taking in a Knicks game, jamming on his guitar, or working for the numerous charities with which he's involved.

"New York, to me, epitomizes what I'm about," says McEnroe. "There's this high energy you can't find anywhere else—energy that's derived from just taking the subway or walking around the streets. But if you know the city well there are also quiet places." Johnny Mac isn't only from New York. He is New York.

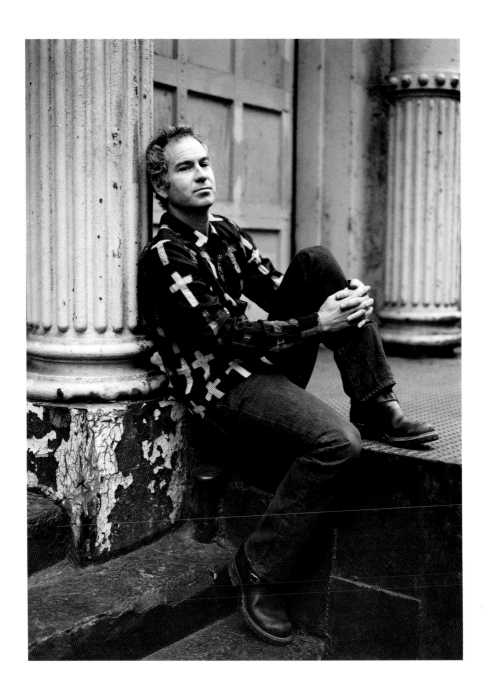

ED KOCH

If New York is the city that never sleeps and never shuts up, then Ed Koch is its poster child. Though he's been out of office for over a decade, the ex-mayor is as ubiquitous as ever. As if a thirty-year political career as a city councilman ('66–'68), five-term congressman ('68–'77), and three-term mayor ('78–'89) weren't enough, Koch now holds down no less than ten jobs. Among other pursuits, he appears on *The People's Court*, hosts his own radio show, lectures around the country, writes for the *Daily News*, is a visiting professor at NYU, and practices law. He has also written ten books, reviews movies, and has no plans to slow down. "I'll work till I die," Koch succinctly explains.

Aside from a stint in World War II, for which he earned two battle stars and a sergeant's rank, Koch has been firmly implanted in New York's metropolitan area. Bronx-born in 1924, Koch moved to nearby Newark, New Jersey, as an eight-year-old and then back to Manhattan to attend City College and NYU Law School. He moved to Greenwich Village in 1950 and has stayed ever since. Would he ever leave? "No," exclaims Koch. "Leaving New York would be like death!"

As mayor, Koch resuscitated New York's sagging economy and reinvigorated its dampened spirit. Entering office in the late 1970s when New York was teetering on bankruptcy, he balanced the city's budget for the first time in fifteen years. He also started one of the largest urban housing programs in the nation, and in so doing, revitalized the Bronx. But salvaging New York City's sagging pride is something of which Koch is most proud. Koch gave New Yorkers a reason to believe that their city, like their feisty front man, could not be pushed around. "If I was to harness the energies of the people of the city of New York and give them back their pride, I realized I would have to become bigger than life," he explains. "So I did."

Through all his accomplishments, Ed Koch may still be best known for his catch phrase, "How'm I doing?" which he constantly asked people while pounding the pavement as a congressman and then as mayor. With the either-you-love-him-or-you-hate-him Koch, the question elicited either an embrace or an egg-in-the-face. Today, as a journalist and judge, he's still controversial. Whatever you think, New York City is a prouder, richer, and more charismatic city because of him. Keep it up, Mayor Koch. You're doing great.

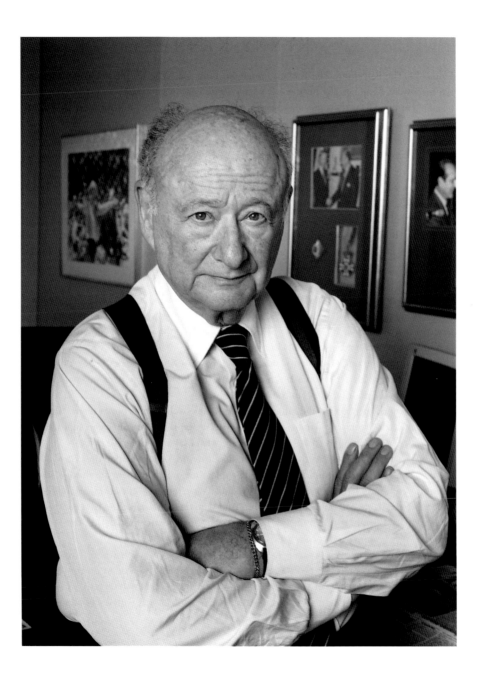

KENNY KENNY

Studio 54. The Palladium. The Tunnel. Limelight. Life. Spa. Where's the hot spot? Who's got the in crowd? Keeping tabs on the city's club scene is a difficult task, with the place-to-be changing as quickly as the songs that blare from the speakers inside. But for New York's clubbing cognoscenti, sniffing out what's in vogue has always been easy. That's because if a queen with six-inch spikes and a getup to die for is manning the door, you know you've found nightclub nirvana. Kenny Kenny is New York's most fashionable doorman—if he lets you in, you know you're "in."

That, however, is a big if. Unless you're Leonardo DiCaprio, standing patiently and longingly outside a happening club only to be turned away is a New York rite of passage. Kenny Kenny, though, is on the right side of that passage. "I have a reputation of being a bitchy queen," he admits. "But I don't get off on telling people that they can't come in. Who wants to tell somebody who's probably adorable and a really good person that they can't come inside because they're just not trendy enough?"

Empathy from a doorman? Exclusion is something Kenny Kenny's very much in tune with. "I was born and raised in Ireland, which felt like a concentration camp," he laments. "I felt like someone who had been dropped in the wrong place." After years of ostracism ("my effeminate traits emerged at a young age"), Kenny fled to London, and then New York. Arriving here at the age of twenty-two, Kenny immediately felt "the gritty, edgy, and vibrant" side of the city. His outrageous outfits created a buzz, and Kenny was soon approached by legendary party promoter Suzanne Bartch, who asked him to work the door at her new club, Savage. "That's how I became the door whore I am today," he laughs.

In his role as gatekeeper, the rather reserved Kenny, well, comes out at night. "I'm quite shy, retiring, and rather anonymous during the day," he explains. "My alter ego appears at the door, where I am very aggressive, bold, don't care what I say to people. It's my stage."

And what a drama it is. As to who gets in, just listen to Kenny slice up the crowd. "First, there are the VIPs, the beautiful, well-dressed people. You could hate them but they get in right away, and they don't have to pay. Then you have normal customers—the average good-looking people." Kenny takes a breath, and then sighs. "And then there are those you have to weed out. They are what I would consider cheesy. Badly dressed, no deportment, bad hair, bad taste, bad accents, lousy grammar. Bad, bad, bad."

After fifteen years of party patrol, Kenny still gets a kick out of his work. "I've gotten to know some great people," he says. "Some go on to have kids. I'll see them on the street and they say, 'Hi Kenny! We met at your club!' It's so sweet." But working 10:00 p.m. to 4:00 a.m. and being cursed at on a regular basis can get old. "My eventual goal with nightclubs is to give them up," jokes Kenny. "Part of me wants to go to Italy and raise goats."

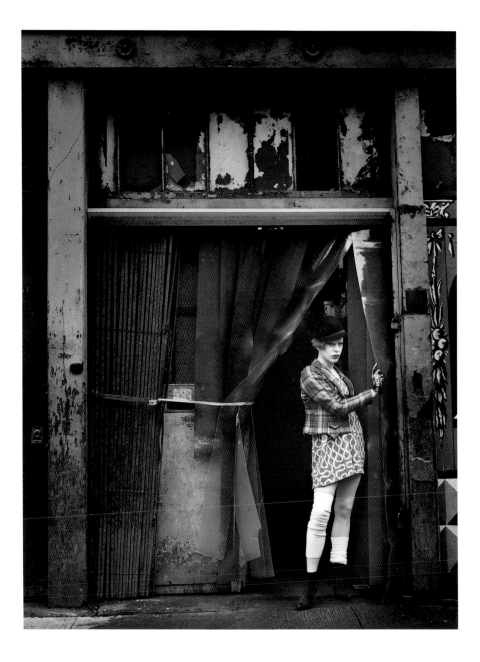

KITTY CARLISLE HART

Doyenne. Noblesse oblige. Joie de vivre. All of these French phrases have been co-opted by the English language. And all three accurately describe Kitty Carlisle Hart, New York City's grande dame of the arts. Born in 1910, this ageless Park Avenue socialite is as vivacious and elegant as ever. After decades of undying passion and support for the worlds of theater, music, and film, Hart continues to enrich our city's artistic life both on and off the stage.

Originally from New Orleans, Hart moved to New York at a young age and attended the prestigious Dalton School (she is its oldest living alumnus) for some time before moving to Europe. After studying in Paris and in London at the Royal Academy of Dramatic Art, Hart returned to New York to pursue a career in the theater. She also pursued a man in the theater; in 1946, she married legendary playwright-director Moss Hart and was with him until his death in 1961.

Hart's self-described "spotty" career has cut a diverse swath across the arts world. Beginning as an opera singer and a star of Broadway musicals and radio shows, Hart also appeared in several films during the early 1930s, including the Marx Brothers classic *A Night at the Opera*. She is perhaps best remembered though for her television game show appearances in the 1950s and 1960s, particularly on the hit show *To Tell the Truth*.

But don't fret if you were born in the last third of the twentieth century and haven't experienced this entertainer extraordinaire. The nonagenarian is still singing American classics on stages all over the city and beyond. "My daughter, the doctor, won't let me do too many performances at once," she complains. "But I would like to be on the road all the time. I love touring. It's simply marvelous."

Marvelous is how many people would describe not only her performances of the arts but also her support of them. From 1976 through 1996, Hart chaired the New York State Council on the Arts and democratized the traditionally elitist organization. Dispensing public monies to museums, theaters, and other like-minded institutions desperately seeking handouts, she wielded substantial power and influence. "When I took over, most of the money went to big establishments like the Metropolitan Museum of Art," explains Hart. "But I was like Johnny Appleseed, running all over the state and funding smaller, grassroots organizations. And let me tell you something, most of them are still around today."

Those organizations probably learned about longevity from Hart herself. If her onstage durability isn't astounding enough, just listen to her discuss her enviable social life. "I have lunches and dinners and I entertain," she says. "I go to the theater, I have opera tickets, and I travel. I'm going to London, because they are performing a play of my husband's, and before that I'll visit a friend in Marrakesh." Kitty Carlisle Hart, you might say, hasn't missed a beat.

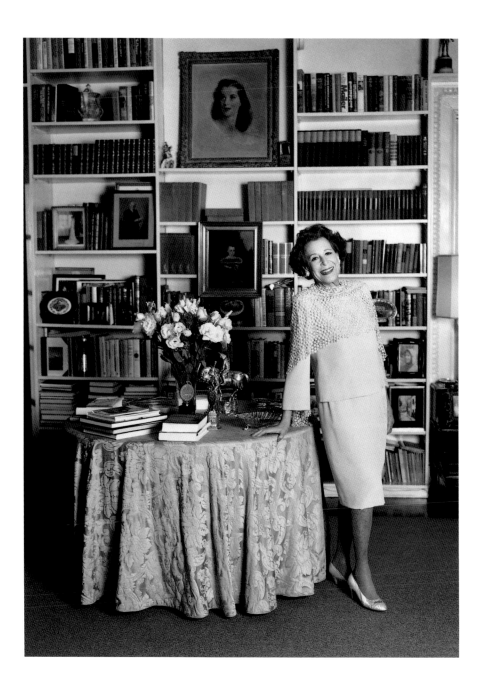

FREDDY "SEZ"

Back in 1988, when the Yankees were in a lengthy slump and in need of a pick-me-up, a retired truck driver named Freddy Schuman attended a Yankees game carrying a big steel pan. Some fans bring binoculars, others tote scorecards, but Freddy decided to bring kitchenware. A decade later, Freddy has banged his way into the hearts of the Bomber faithful. "It's a whole lot better than sitting in a rocking chair," Freddy says, or, as his sign reads, "SEZ."

There will always be the pinstripes, the ballpark franks, and the short porch in right field. But for the past ten years there has also been Freddy "Sez," who roams through the stadium banging his old-fashioned chromium steel pan with a spoon and waving a tattered, handmade YANKEES sign. His truck-driving career is a distant memory, as he is now the Yankees most famous, if not loudest, fan. "I crave the excitement and the adulation of my fellow fans," beams Freddy. "Because if not for the fans, then I'm nobody."

When the Yanks are in town, Freddy gets to the stadium a few hours before the first pitch. (A lifelong Bronx resident, he lives just a short distance from the ballpark.) After passing out his free Yankees newsletter, he works his way around the entire stadium, spending three innings in each tier. When Freddy bangs his pan with his outsized steel spoon, the crowd, well, sizzles. When he tires, he takes his very own seventh-inning stretch, handing off the pan and spoon and letting the crowd cook up its own excitement.

Steinbrenner has yet to put him on the payroll or honor him with a Freddy "Sez" Day. Then again, the Yankees—now a dynasty once more—have invited the little drummer guy to ride a float in the World Champions' ticker-tape parades and clank his skillet through the Canyon of Heroes. Making that glorious ride down Broadway celebrating the Yankees dominance, one could say that Freddy "Sez" and his beloved Bombers go out with a bang.

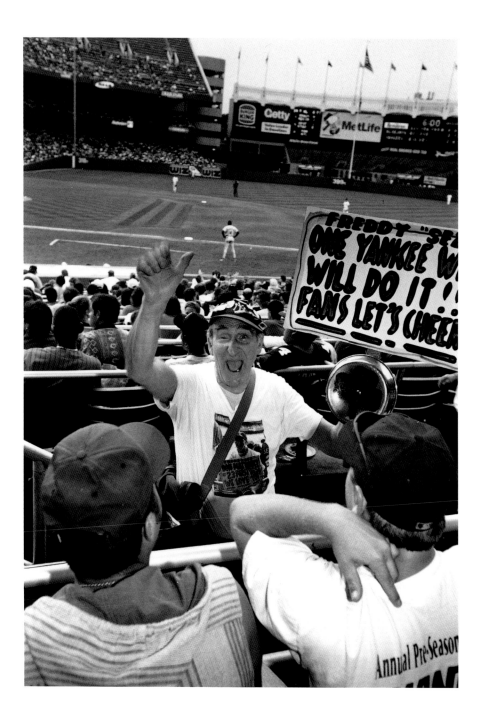

TIMOTHY "SPEED" LEVITCH

Whether he's captaining a double-decker bus tour or leading troops on foot through the streets of Greenwich Village, New York tour guide Timothy "Speed" Levitch is, well, quite a trip. This isn't your father's "Statue of Liberty on your left, Chrysler Building on your right" tour of NYC. "Speed" (a high school nickname) is undoubtedly our most impassioned and eccentric tour guide. His stream-of-consciousness soliloquies and strong opinions give those willing to listen an eccentric expedition through not just the city, but also his outrageous mind.

With a nasal voice that plays like a tape recorder on constant fast forward, Levitch displays a remarkable facility with language and an encyclopedic knowledge of all things New York. Levitch on the Brooklyn Bridge: "There's no victory in its subjugation of me. The best moments of our friendship are when I become the Brooklyn Bridge, when I realize that we are equals." Levitch on Grand Central Station: "Commuters are people running from what Walt Whitman would call the quick, abrupt questions that rise within ourselves. Those questions orchestrate rush hour." On the famous Lower East Side eatery Katz's Deli: "Two adults per sandwich, and the most difficult aspect of digesting the food is the lineage that goes along with it—the history of the people who dine on that food and the poltergeist energy around it." You get the picture.

Not many would have predicted that a graduate of the ultra-exclusive Horace Mann School would end up a New York City tour guide. Growing up in the Riverdale section of the Bronx and then the suburbs of Westchester County, Levitch never really got a true taste of Manhattan. But at seventeen, he took a life-altering train ride into the city and discovered this "fantasia of humanity." He was hooked, and now, more than a dozen years later, has never parted from this "Olympus of gregariousness." Ironically, though, Levitch has never found a home. Chronically homeless, he spends his nights "couch-surfing" on the sofas of his acting and bartending friends (or sometimes on the occasional park bench). This way, he explains, he "can remain in confluence with the chaos of the city."

In 1988, Levitch's shtick was the subject of an entire movie called *The Cruise*. The title comes from Levitch's worldview and philosophy, which he describes as "an effervescent homage to the present tense." His goal in life is simply "to fall in love with every person I meet." In many ways, Levitch is the ultimate nonconformist, chief eccentric in a city full of them. But when asked why he gives tours, he reveals that, in at least one way, he's just like the hot-blooded rest of us: "I don't do this to entertain tourists—I do this job to pick up women!"

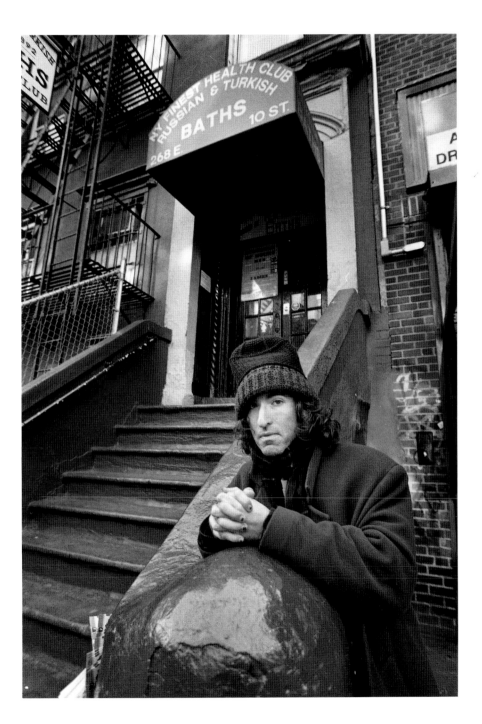

SYLVIA WOODS

New York can make a very strong case for being the best food city in the world. No need to travel to Bombay for Indian; just head over to Sixth Street and Little India. Don't bother flying to Tokyo for sushi; chefs slicing up delectable pieces of raw fish can be found all over the city. And no need to cross the Mason-Dixon line for the best in southern cooking; just head to northern Manhattan. For over forty years, Sylvia Woods has been serving down-home cooking way uptown. Sylvia, along with her eponymous restaurant, is synonymous with the collard greens, fried chicken, and barbecued ribs that have made her the undisputed Queen of Soul Food.

But the seventy-something-year-old gastronomical icon hardly views herself as royalty. "I say to my children and grandchildren, even employees, don't walk behind me, let's walk side by side," she proudly maintains. "We are all one family." And that sentiment extends beyond just her blood relatives. Sylvia considers every customer a member of her clan. "I try to make everyone feel like this is home away from home," she explains. "I sit and talk with the customers. I want them all to know where I came from. I want them to know that this didn't happen overnight."

Sylvia, born and raised in the small town of Hemingway, South Carolina, came to New York to start a new life. But she hardly had the restaurant business in mind. Growing up in the segregated South, Sylvia had never even been inside a restaurant. So when she walked into the luncheonette at 328 Lenox Avenue looking to wait tables, she didn't know what she was getting herself into.

What started as a waitressing gig would grow into a Harlem landmark. She would buy the restaurant and see it through four expansions. Now, with a separate branch in Atlanta run by her daughter and another outpost scheduled to open at Kennedy Airport, Sylvia is creating a franchise brand. But she doesn't only feed people at her restaurants. In 1992, she launched Sylvia's Soulfoods, a line of prepared delectables including everything from okra to hot sauces. She has even published two cookbooks. "I didn't even go to cooking school," she confides. "I just made all the recipes up!"

Despite the other projects, Sylvia's primary passion is the Lenox Avenue restaurant. "They only call me Sylvia, but I am Harlem," says the Queen unabashedly. "I've had opportunities to open up a restaurant downtown but I feel like Harlem needs me as much as I need it." Her devotion has paid off. The restaurant isn't just a requisite stop on the uptown tourist bus route; political and Hollywood stars frequent the place. Sylvia's walls are covered with autographed headshots. Recently, the most famous soul food aficionado of all, President Bill Clinton, came by for some grub. "That boy can eat," laughs Sylvia.

But even if you're the leader of the free world, don't expect special treatment—southern hospitality dictates that every customer is important. "I really just love people so much and love making them happy," she beams. "And I enjoy it when they enjoy what I give them." And when the huge, delicious, steaming portions start coming out of the kitchen, it becomes very clear—Sylvia's got a lot to give.

HENRY STERN

Henry Stern is Parks Commissioner for the City of New York. Combining good humor with a $170 million budget and mixing peculiarity with power, Stern is as famous for getting the job done as he is for having fun doing it.

To start, there's the legendary "park names," or *noms de parc*, as Stern prefers, that he confers upon people. What began as a way to smooth radio communication between his employees has become a badge of honor within the department and beyond. "Starquest" (Stern) spends his days traveling the city along with "Whiplash" (his deputy), "Gator" (his assistant), and "Wonder Dog" (his golden retreiver, a.k.a. Boomer when off duty). Stern boldly calls his current boss, Mayor Giuliani, "Eagle," a reference to the mayor's receding hairline, and a sobriquet he grudgingly accepts.

Stern's nickname game is just the tip of the iceberg. As one of his staffers explains, "everything you've heard about him is true." Like Stern's dressing up in costume for park events as a Druid or a tree, in a spacesuit or a toga. ("Better the Parks Commissioner dresses up than the Police Commissioner," Stern claims.) Or his including in his annual "State of the Parks" address a lengthy dramatic reading from *The Great Gatsby*. Or his having an aide hit a clicker each time someone would pet Boomer; the counter broke at 10,390.

But make no mistake, this man is an accomplished commissioner. He has made the city parks cleaner and safer, planted more new trees than they have in any other city in the country, and added more than 1,600 acres of parkland to the 28,000-acre system. He is a political animal who has garnered significant power in the intensely competitive world of New York City politics.

A native New Yorker, Stern graduated from the Bronx High School of Science before going on to City College and Harvard Law School, where he was the youngest member of his graduating class at the age of twenty-two. Politics was a passion from an early age—at nine years old, he was a radio sensation as a child genius discussing the current events of the day.

Decades later, there is no doubt now that, odd behavior notwithstanding, Stern doesn't miss a beat. After over thirteen years as Parks Commissioner, he is still impassioned about his post. "The job of the Parks Commissioner is to find joy and have fun—because Parks is the department of good times," Stern exclaims. Sitting on his couch surrounded by dozens of cute, cuddly, and colorful stuffed animals, it seems that Starquest is having a blast.

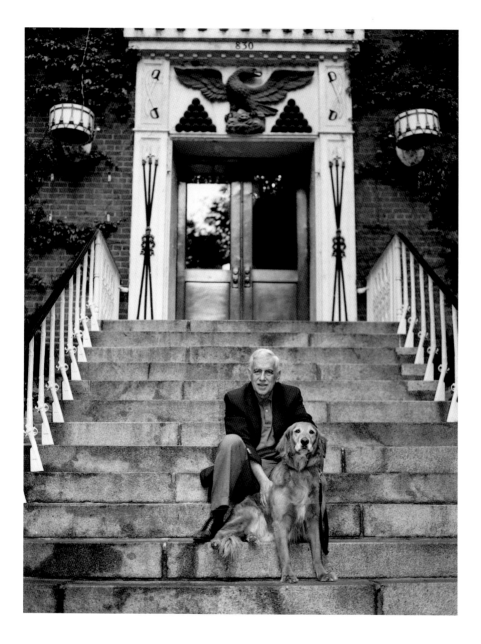

HILLY KRISTAL

Along with famed sports arena Madison Square Garden (as Seinfeld points out, it's not on Madison, it's not a square, and there's no garden), Hilly Kristal's oddly named downtown club, CBGB OMFUG, is one of New York's great misnomers. For three decades, this legendary music venue—short for Country, Blue Grass, Blues, and Other Music For Uplifting Gormandizers—has discovered and showcased some of the world's greatest rock bands. Not country bands, not bluegrass bands, not blues bands, but rock bands. To understand how this came to be, you must hear the story of Hilly Kristal and how his unassuming little club in the Bowery became a launching pad for legendary musicians and ground zero for New York's rock musically obsessed.

When Kristal opened CBGBs in 1971, he was already enmeshed in a lifelong love affair with music. After studying violin as a child, Kristal moved to New York in his twenties to pursue a folk-singing career. While modestly successful (he has appeared at Radio City Music Hall), Kristal earned extra money managing the legendary Village Vanguard club. Kristal soon struck out on his own, starting a club called Hilly's on West Ninth Street, which he eventually moved to the Bowery and renamed CBGBs.

Pouring his whole life into the club, Kristal did everything from booking to cleaning. "I used to mop the floors at the end of each night. At one point I even lived in a cubbyhole in the back," he says proudly. "But it's hard to say where the work stopped and the pleasure began." Kristal started the club to do country, bluegrass, and blues. "That's really what was popular at the time," he explains. "But there were all these kids around New York who were playing this cutting-edge punk rock music, and there was no place for them to play." Necessity being the mother of invention, Kristal instituted a rule that only original music could be played in his club. From that, New York's "birthplace of punk rock" was born, and country crooners were sent packing. "We became like a workshop," he remembers. "Most of the bands were okay, some were not good at all, but a few really had the spark."

To say that such acts as Talking Heads, The Ramones, Blondie, Patti Smith, and—in more recent years—Living Color and the Beastie Boys simply had "the spark" is a bit of an understatement. The list of bands whose careers Kristal has nurtured is staggering, and it is what makes Kristal most proud.

Although Kristal is a half century older than most of the musicians he supports today, he's still changing with the times, seeking out cutting-edge music and the bands that play it. He's opened a second wing of CBGB, called the 313 Gallery, as a forum for young visual artists, and has a website with MP3's of new music. Still, many things about CBGBs haven't changed. The walls are still plastered with the same old posters and graffiti. The music is still cutting edge and crowd-adored. The executives from the major labels still frequent the club in search of the next big thing. And Hilly Kristal is still there each and every day, New York's aging but ageless gormandizer of rock 'n' roll.

THE SUBWAY DANCER

They slide gracefully across the tiled floor. He is working hard, muscular and nimble, but she seems to move completely effortlessly, her body obeying his every command. He spins her faster and faster, and yet she doesn't get dizzy. He dips her so impossibly low it looks like her body will break in half. And for most of this miraculous merengue, her slender legs don't even touch the ground. It's not surprising that they've attracted a large crowd, and every once in a while, someone steps out from the semicircle of commuters and tourists and drops a coin in the black hat. It's a small price to pay to see Julio Diaz and his phenomenal partner perform in the 42nd Street subway station, but most people give something because Diaz's partner is such a doll.

No, really. Julio Diaz has been performing with his perfectly constructed plastic partner, Lupita, for over a decade. A Colombia native, Julio moved to New York in 1990 and got a job delivering sodas. "I saved the large plastic containers they used to wrap the soda in. I would put the plastic in the oven to make it hard and used it to build her body parts," he remembers. "I used the cotton in mattresses that people threw out to build the doll too." After fifteen days of salvaging and building, going to secondhand clothing shops and wig and cosmetics stores (he bought a wig and the plastic face that displayed it), Diaz had a unique and willing dance partner.

So Julio and Lupita went to Flushing Park to practice their moves. From there, they took their salsa and pasodoble heavy act to Manhattan. Now Julio has a few regular venues—42nd Street and Penn Station in the winter, Central Park and the South Street Seaport in the summer. He's performed at the Copacabana and Casablanca. He even gets hired to do private parties. But he prefers public performances. "I wouldn't trade the energy and excitement of New York for any other place," he explains.

Diaz had danced with dolls long before he came to the United States. His first success with a doll came when he built one for a local bar owner. Distraught over his wife's leaving him, the barman asked Diaz to build an effigy of her so he could burn it with her clothes. But Diaz built such a good doll that the doll lived a few hours longer than expected. "I danced with the doll before I burned it, and everyone thought it was so funny. So I made my own doll," he says proudly. "I danced with it all around Colombia. I became a really good dancer. People went to see me and everything. And I was making more money than the other dancers who would dance by themselves."

So now Diaz never dances alone. And though he and Lupita dance eight-hour days almost without a break, neither of them shows any signs of wearing down. "I love the Colombian music and I love people cheering at me." Why wouldn't they cheer? The couple has chemistry, rhythm, and truly malleable bodies. And performances are free.

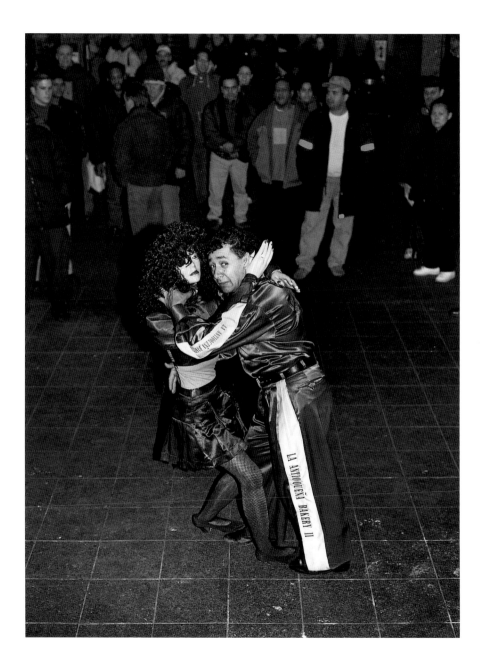

GEORGE WHIPPLE

Just what is Whipple's world? Ask a New Yorker this question and you are likely to get two very different answers. One rather clannish clique will tell you that Whipple's world encompasses prep schools, the Ivy League, a gentleman's farm in Putnam County, and the halls of the city's most prestigious investment and law firms. But a larger, far less exclusive group will answer that *Whipple's World* is that wildly amusing gossip show with that bushy-eyebrowed guy on cable's New York 1.

Both answers are correct. George Whipple III is a white-shoe lawyer by day and a wacky entertainment reporter by night. A graduate of Choate, Columbia College, and Columbia Law School, it's no surprise that Whipple is a highly regarded labor lawyer at a prestigious invest-ment bank. But after he files his last brief and drafts his final employment agreement, this modern-day Clark Kent swoops down from conference rooms in the sky to scour the city for the hottest, hippest, and most star-studded affairs around town.

With a lighthearted, almost campy approach to celebrity news, *Whipple's World* consists of interview snippets with New York's beautiful people and punchy reports on society hap-penings throughout the city. At the show's core is Whipple, dressed to the nines and always appearing to enjoy himself as much as the celebrities he's interviewing. "What makes my reporting different than others," says Whipple, "is the fact that I'm doing this for pleasure. This is my relaxation. I'm having fun so I think the viewer has fun too."

What the viewer often notices are those big, bushy eyebrows. "When I first went on tele-vision, I decided that I should create a sort of mystique, something to make me instantly rec-ognizable," he recalls. "I initially decided to carry my Jack Russell terrier everywhere. I would be the reporter with the dog." Someone soon pointed out that Whipple's most distinctive char-acteristic was right on his face. "So I guess I've become the 'Eyebrow Man,' " he chuckles. (Whipple claims to have inherited his eyebrows from his great-granduncle, Daniel Webster, whose statue stands in Central Park.)

His television work doesn't come as a complete surprise. After spending seven years at Cravath, Swaine & Moore (arguably New York's most distinguished law firm), a burnt-out Whipple left the law and pursued a successful career as a freelance photographer while also studying film at NYU. "Eventually," he explains, "I wanted to get in front of the camera. I thought that I could do things that not everybody behind the camera could do."

Whipple was right, and for that, he doesn't just have to stick to his day job. But surely, this sort of moonlighting must raise some "eyebrows" at the bank? Not at all, says Whipple. "I'm very successful in attending to matters at the office—so what I do after work is okay with them."

But as to which job he likes better, Whipple hesitates. "I enjoy the balance between the intellectual rigor of the law and the excitement and fun of the glamour industry. I'm excited by celebrity and fame. There's a level of charisma and excitement that you don't see in ordi-nary life—and I guess I'm a moth to that flame." Besides, adds Whipple, "I think it might take the fun out of it if I gave up my day job."

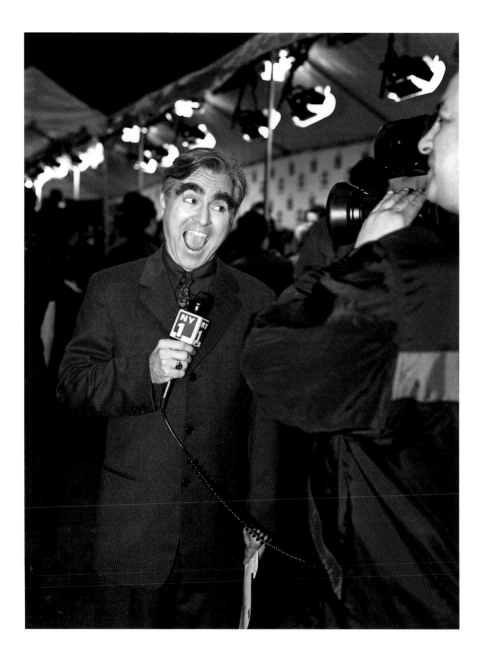

SPIKE LEE

Ask New Yorkers about Spike Lee and you're likely to get a wide range of opinions, running the gamut from brilliant to bigot. Whatever your view, two incontrovertible facts remain: he is one of the most influential filmmakers in contemporary cinema and one of the New York Knicks biggest fans. Through his dual passions—making films and cheering hoops—Lee has achieved iconic status as a New York original.

Born in Atlanta, Lee moved to the Fort Greene section of Brooklyn at the age of two. Other than four years at Georgia's Morehouse College, Lee has never left New York. After jettisoning his childhood dreams of becoming a professional athlete, Lee studied film at NYU and then set up his Brooklyn-based film company, Forty Acres and a Mule. (The company's clever name comes from the property that was promised to slaves during post–Civil War Reconstruction.)

From his very first feature film, the independent cult hit *She's Gotta Have It* (1986), critics and fans recognized a special talent. A prolific filmmaker, Lee has made fifteen films in fifteen years. His skills extend beyond directing and producing; in the tradition of his New York colleague Woody Allen, he also acts in most of his films. (Lee has also created numerous award-winning commercials with his own advertising agency, Spike DDB.)

New York neighborhoods often play crucial roles in Lee's works. In his breakout movie, *Do the Right Thing*, Bedford-Stuyvesant is as much of a character as Sal or Mookie. Other Spike Lee films—from the epic bio-pic *Malcolm X* to the frightening *Summer of Sam*—are as much paeans to particular neighborhoods (Harlem and the Bronx, respectively) as they are about fascinating events in our city's history.

His work is, first and foremost, about African-American culture, but Lee bristles when people pigeonhole him as a race storyteller. "I think, actually, that my first decade as a filmmaker has covered a broad spectrum of stories," he explains. "It has also covered the broad spectrum of the African-American community as a whole, and the different stories that we share. Not everything I do involves race, but when I do tell a story regarding race, we have to go at it strong."

In recent years, Lee's most recurring and visible role has been courtside at Madison Square Garden. Lee is a proud Knicks fanatic and a Knicks opponent's nemesis. Long before he could afford the nearly $2,000-per-game front-row seats that he and his wife, Tanya, regularly occupy, Lee cheered from the nosebleeds. These days, he's practically a sixth man on the floor, high-fiving the Knicks, yelling at the refs, and talking trash to the other team.

His beloved Knicks still take a backseat to his work and his family. He and Tanya live on Manhattan's Upper East Side with their two kids, son Jackson and daughter Satchel. As for Lee's future career goals, he's typically succinct: "I want to keep making movies, I want to keep telling stories, and I want to find imaginative ways to do it." Don't bet against him.

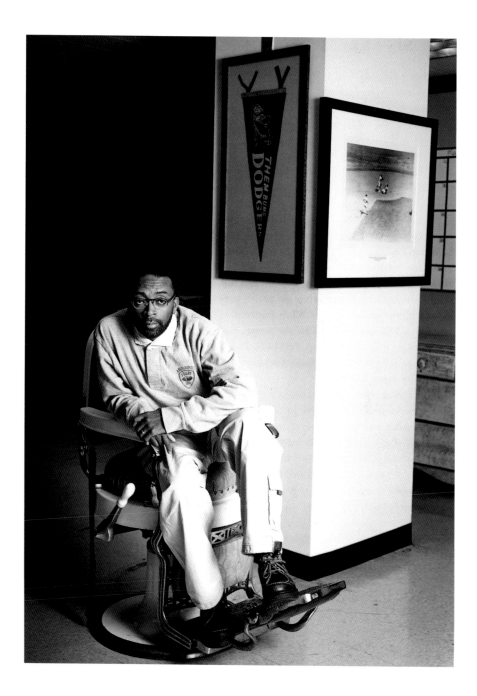

SISTER MARLANE, THE BIRD LADY

With her curly, waist-length black hair, snow white face, garish cherry red lips, and thick eyelashes, Sister Marlane looks otherworldly. And if, as she insists, she hails from heaven, then she just might be. But more realistic origins might just be Central Park. There, at least, is where she spends most of her time. "My family is the squirrels and birds of this beautiful park," she explains. For Sister Marlane, Central Park is heaven.

A regular day for Marlane begins quietly enough, feeding Central Park's birds with bags full of food she brings from home. Like Dr. Doolittle, the birds of Central Park flock to her, land on her, and follow her around. "I have a relationship with them," she says modestly. "They sense when you love them."

Apparently, the birds aren't the only ones who've sensed Marlane's love. In 1990, she attracted quite a bit of attention by befriending a wild Central Park groundhog that came to be known as Fifth Avenue Phyllis. Phyllis was leading a quiet, reclusive life near the Central Park Zoo when Marlane came along and tamed her. Their relationship turned into quite the tourist attraction as crowds would gather round and watch Phyllis perform the tricks Marlane had taught her: holding a banana while she peeled it, begging for bits of oatmeal cookie, and coming out of her burrow on cue. When Phyllis didn't appear as usual one day, a media frenzy erupted and thousands feared for the worst. Marlane placed herself in the middle of it all, keeping vigil with a sign saying: PHYLLIS, PLEASE COME HOME!!! But the fairy tale did not have a fairy-tale ending. "Phyllis was killed by the Zoo veterinarian," Marlane says, an accusatory note in her voice.

The animals aren't the only things in the park that Sister Marlane looks out for—she cares for the landscape and the people too. "One day I spent eight hours shoveling mud because a tunnel flooded and the drains were not working," she recalls. Talk to her long enough, and a very strong Walter Mitty quality emerges. "I've done things that no one else has done or tried to do," she says. "I've solved crimes that other people couldn't solve, cleared out drug dealers, rescued hostages when it couldn't be done." She's also, so she says, modeled, performed in a cabaret, run for mayor (twice), governor (once), and even president (once). "I was never informed that I won an election," she admits, "even if I wasn't really serious about running."

She explains that the thread that runs through all of these activities is her wish to make the world a better place—"My crusade to save the world with love and humor." With her munificence toward the park's creatures and her fantastical tales of fighting its evil spirits, she's moving toward her goal.

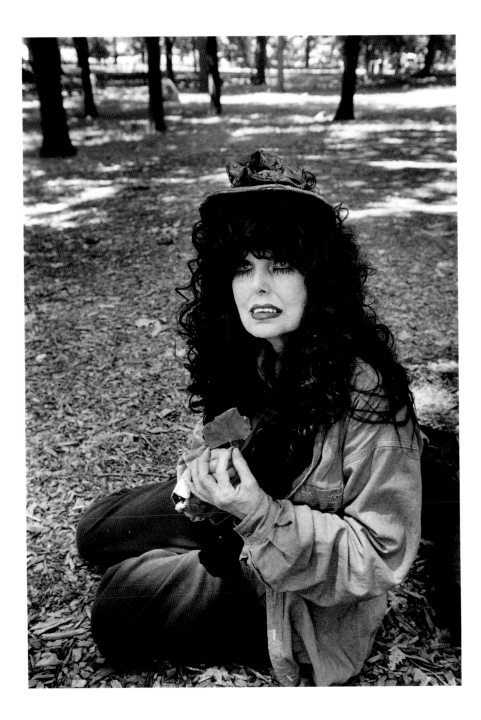

MARKET DUDE

"Stock Market Crashes!" the *Daily News* screams. "Bull Market Mania!" *BusinessWeek* rages. You have all seen these bombastic headlines in the beloved New York tabloids and finance pages around the world. Frequently accompanying such banners, whether the market swing is way up or way down, runs a photo of Allan Gershowitz, also known as Market Dude. Amidst hundreds of hustling, bustling brokers on the floor, Market Dude always stands out from the crowd. With his expressive, often suntanned mug and enthusiastic histrionics (not to mention a booth on the floor directly underneath the photographers' gallery), Allan Gershowitz is the face of the New York Stock Exchange.

Like much else in his life, Gershowitz's celebrity is sheer happenstance. The son of a postal worker, Allan grew up in a poor section of the Bronx. "I shared a room with my sister till she got married; we couldn't afford any more," he explains. In 1968, with a draft-preventing hip injury and little direction in his life, Gershowitz literally wandered into a Wall Street career. "One day I decided that I needed a job, so I took the subway into Manhattan to look for work. I was reading my newspaper and paying little attention when I realized I was at the Wall Street station. It was the last stop before Brooklyn, so I figured I should get out." With a scarcity of men around because of the Vietnam War, Gershowitz easily landed a clerical job at a Wall Street brokerage firm. The legend of Market Dude was born.

One day, Gershowitz, tired of ministerial work, volunteered to fill in for a vacationing floor clerk. Entering the stock exchange floor, he thought he had died and gone to heaven. "I loved it," exclaims Gershowitz. "You were with all your friends and you could run around and throw papers on the floor." At the end of the day, Allan was so excited that he asked his supervisor if he could stick with a job on the floor, and his firm found a spot for him. That was thirty years ago. He's never left.

Ascending from clerk to broker to an owner of a seat on the exchange (which goes for as much as $2 million today), Gershowitz is a classic Wall Street success story. But becoming the most photographed broker on the street is a wrinkle that he never aimed for or expected. With every market gyration, Gershowitz's face shows up all over the place, from *Fortune* to the *International Herald Tribune*, from the *L.A. Times* to *Newsweek*. The only effect all of the publicity has had on his business is that he has to put up with constant ribbing from his buddies on the floor. "Pretty Picture Boy. Hollywood. I've heard it all," Gershowitz chuckles (indeed, he does have the demonstrative face of an actor). "The guys give me a pretty hard time about it, but it's all in good fun. The floor is the greatest place in the world to work, I would never want to work anywhere else. It's like a second home." Spoken like a true Market Dude.

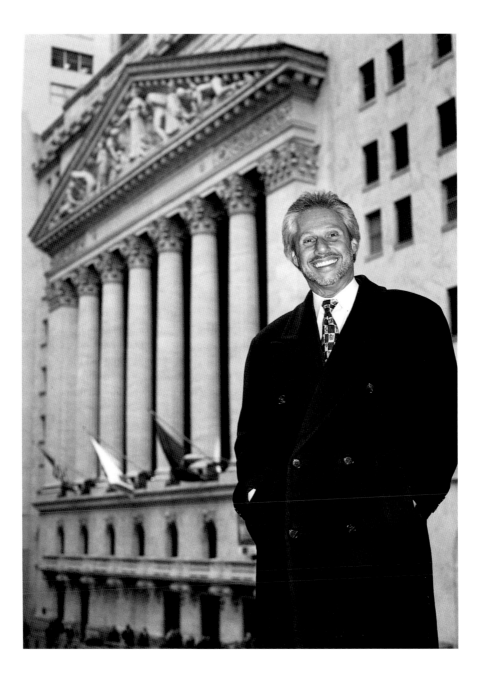

BASH

Do you need to convince a co-op board that your cocker spaniel will be an upstanding member of that Park Avenue duplex you always wanted? Does your Yorkshire terrier need to get over homesickness after living in London for five years? Or do you just want your mutt to stop pissing on the floor? Enter Bashkim Dibra, or "Bash" to his devotees, dog trainer to the stars. With a list of clients that includes names like Kissinger, Baldwin, and Broderick (not to mention Fluffy, Muffy, and Fido), he has more success stories under his leash than you can shake a stick at. And according to him, the secret is easy—"I see everything from a dog's point of view. I actually think like a dog."

Born in Albania, Bash found himself caught in a Yugoslavian prisoners' camp for most of his early childhood. It was there, under the watchful eyes of guard dogs ("my refuge," says Bash), that this modern-day Dr. Doolittle first discovered his ability to communicate with animals. Eventually, he and his family escaped and emigrated to the Bronx. From there, Bash's unique skills took him to Hollywood, where he worked with film industry legends Benji and Lassie. But while film and photo shoots were "wonderful," Bash ultimately decided to return to New York, where he has become our city's resident *vox canini*.

When New York's well-heeled owners have problems with their dogs, or when dogs have problems with their owners, Bash is their first call. Bash is as much a family therapist as he is a trainer, making sure that owners understand the unspoken (except to him) needs of their dogs. "Every person is different, every dog is different," says the man some call the Dog Psychiatrist. His job, he explains, "is simply to make the magic happen—to achieve that indescribable chemistry between a man and his dog." And at $300 per hour, making the magic happen certainly doesn't come cheap.

Bash has not only amassed an enormous and loyal client base but has done much for canine causes throughout the city. He created the first dog walk for the ASPCA in the early nineties, and has helped raise awareness of canine cancer through the American Cancer Society. Bash is also committed to the leisure life of dogs. With the help of the NYC Parks and Recreation Department, Bash has created New York's first "dog playground." Complete with water troughs, an obstacle course, and plenty of places for non-dogs to sit and chat, the Van Cortland Park playground is a hit with dogs and owners alike.

"My goal is simply to show people that having an animal energizes your life," says Bash, who has written three books on his favorite subject. In an effort to diversify his client base, he's now at work on a book about cats. But New York's number one animal lover is deep down a people person. "While I love all my dogs," explains Bash, "what I really like is people. There is nothing better in this world than people enjoying their pets. That's what life is all about."

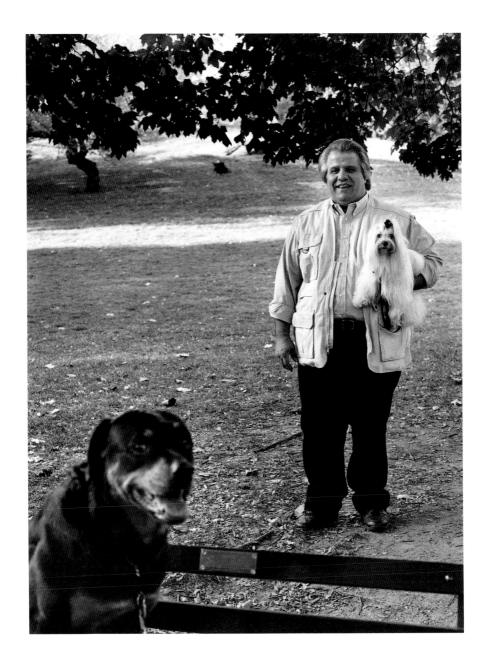

DICK ZIGUN

It's hard to imagine just how popular Coney Island was a century ago. Picture a far less sanitized Disney World on Brooklyn's south shore, where each summer, millions of visitors flocked to the boardwalk and beaches. It was the world's greatest amusement park in the world's greatest city. After World War II, Coney Island's popularity began to wane, and by 1979, the area was well past its prime. Crime was way up, buildings had fallen down, and most of the locals who had seen their neighborhood flourish in the first half of the century had given up all hope. But in swooped Dick Zigun, an idealistic impresario with an eye for the eccentric and a passion for the absurd.

Zigun grew up in Bridgeport, Connecticut, which, as circus legend P. T. Barnum's hometown, inspired an obsession with the circus, amusement parks, and vaudeville acts. Armed with two degrees in theater (Bennington College and the Yale School of Drama), Zigun, like many of his classmates, moved to New York to pursue his dreams. But instead of seeking fame on Broadway, Zigun sought the crazy culture of Coney Island.

"I had the advantage of not growing up in New York," explains Zigun. "People who had grown up in the city were very bitter about what had happened to Coney Island. Their childhood playground had been burned and destroyed. I didn't have that association when I showed up. Even though it was a bit tacky and trashy, I still found it quite charming. There was an advantage to being an outsider and seeing its potential."

So, with fresh eyes and big hopes, Zigun tapped into the creativity and expressive flare that Coney Island had long nurtured. He created Coney Island USA, an arts organization with the mission to preserve what was left of Coney Island's heyday and revive its lost glory. For his first project he restored the wax museum. From there, Zigun created the annual Mermaid Parade, a festival of fishtail-wearing men and women traipsing down the boardwalk. Today, it attracts thousands of spectators to Coney Island each June.

While there, crowds might also take in Zigun's Sideshows, his very own "10 in 1" freak show, where for one price you can see ten different alarming oddities, including a sword swallower, a snake charmer, a contortionist, and a man with twenty-five thousand tattoos. "It's now the only '10 in 1' in America," says Zigun. "In the 1940s, there were more than two hundred different sideshows touring America, but they've died out because they are not economically viable. If there's going to be one place in the country that keeps a '10 in 1' alive, it's Coney Island."

Fueled by his peculiar tastes and oddball dreams, Zigun has breathed life into the city's artistic community and helped to restore a sagging American landmark. "It's my obligation to work from the memory of what I loved when I first got here and from what I know had been here before," says this spirited conservationist. "It's my obligation to keep the spirit of Coney Island alive."

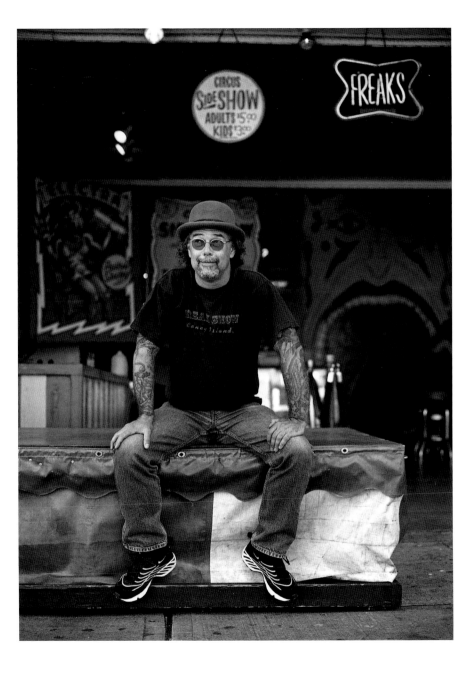

JIMMY BRESLIN

Jimmy Breslin, perhaps the best newsman this city has ever seen, can do most anything with words. But one thing he will never do is mince them. Spend an afternoon with the fiery journalist and bear witness to a one-man rant like no other. Whether the subject is the state of journalism or the state of his liver, Breslin tells it like it is.

With a Pulitzer Prize–winning career spanning five decades and five newspapers (not to mention numerous novels, screenplays, and stage plays), Breslin is eminently qualified to weigh in on today's news reporting. Just ask him: "Years ago [in the newsrooms] you couldn't hear a thing with all the typewriters. There was smoke everywhere and all this energy and excitement. And the paper read like that. Today the reporters have great résumés but sit there and look at the computer screen as passively as if they were watching a sitcom—and then they write passively. No noise, no smoke, no excitement. Then, at the end of the day, they go to a health club and then home. They're the most boring set of people I've ever seen and they write boring."

No one would ever call Breslin boring. One reason for this, he insists, is that instead of lifting weights, he was busy curling pints. "I used to finish work and run to the bar," he explains. "You had a memory bank there with all these old guys telling great stories and anecdotes. I never had a bad idea in the bar. I never had an indecent thought in the bar. I never had anything in the bar but fun." Recently, however, an embattled liver, a brain embolism, and a reduced tolerance for hangovers finally forced Breslin to give up his famed drinking life.

As a young boy in Queens, Breslin published his very own neighborhood newspaper. "I used to go to the local deli and just listen to the people talk," he says in his classic raspy voice. "I once overheard two women talking about Mr. Lustig being impotent. I didn't know what the word meant but I ran home and printed it up. That caused a riot!" From those auspicious beginnings, Breslin started as a copy boy and moved to the sports desk before finding his voice as a famed columnist for the *Herald Tribune* (now defunct), the *New York Post*, and *Newsday*, where his column presently resides.

While his body of work is legendary, Breslin is perhaps best known for receiving a series of letters from serial killer David "Son of Sam" Berkowitz. (The letters eventually led to the murderer's capture.) Why did Berkowitz choose him? "Well, who the hell else would he write to?" Breslin indignantly asks. "Me! I'm the guy!" If that sounds a little arrogant, well, Breslin would not disagree. "I'm too arrogant to be impressed by anyone," he explains. "That's the way you've got to go out there. And I'm not afraid to be controversial. In fact, I better be. How am I going to be paid if I'm like everybody else?"

Though his brazenness gives him an edge, Breslin attributes the real secret of his success to his two feet. "News reporting," explains Breslin, "simply consists of using your two feet and learning to climb stairs. There are no stories on the first floor." Maybe that's why he lives in a penthouse!

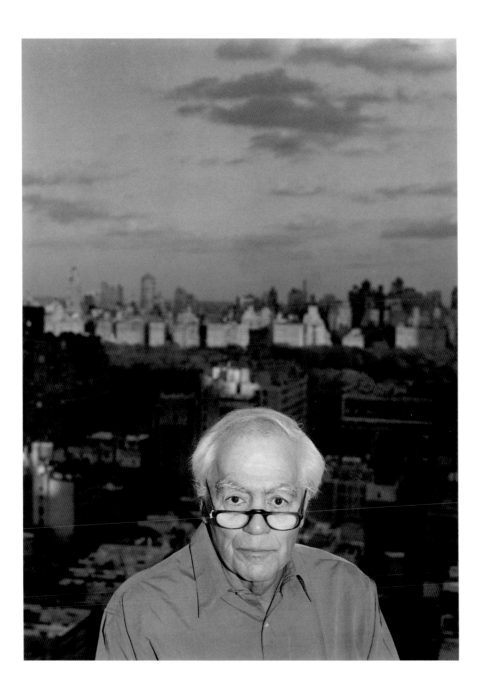

PEGGY SIEGAL

Just before going to bed last night, you saw it on the evening news. Now you're reading about it in the morning papers. The hottest movie premiere of the season came to town, with New York's beautiful people out in full force. After taking in the film at the Ziegfeld, the A-list crowd moved on to the restaurant-of-the-moment for dinner, drinks, and a fabulous party. "How come I wasn't invited?" you ask yourself. "I'm pretty good-looking, I like movies, and, besides, I work right around the corner from the theater!" Here's the problem: you don't know Peggy Siegal and, more important, she doesn't know you.

Peggy Siegal is New York's screening queen. In an industry that places a premium on hype, it's not just who you know, it's who shows up at your opening. And Siegal, along with her part-ner Lizzie Grubman, has the most star-studded, powerful, and interesting Rolodex (or, these days, PalmPilot) in the city. When the studios on the left coast want to create buzz on the right one, Siegal gets the call.

Growing up in northern New Jersey, Siegal always had her nosed pressed up against the window of Manhattan's glitterati scene. "When I was sixteen, I used to get all dressed up, sneak across the George Washington Bridge, and go to Elaine's," remembers Siegal. "If Jackie O. walked in, it was like I had died and gone to heaven." After graduating from Syracuse, Siegal pursued a fashion career until an events-planning friend in the entertainment business offered her a job. The kid had found her candy store.

"I've always had a great passion for films and an enormous amount of respect for the peo-ple who make them," confesses this perenially starstruck fan, who had her own firm before forming Lizzie Grubman / Peggy Siegal Public Relations last year. But the behind-the-scenes planning is not as glamorous as one might expect. Someone has to make sure the theater tem-perature is just right and that there's enough raw fish at the after-party's sushi bar, and, most important, that the seats are filled with the "right" people.

"At the end of the day, we are hired to get publicity," she emphasizes. Though it's impor-tant to have the De Niros and the Paltrows show up, Siegal works hard at concocting a diverse guest list from the worlds of politics, media, and high society. There is, of course, a method to the mix. By inviting Regis or Rosie, there's the possibility of their plugging the film on their show the next day. One mention, Siegal explains, can pay ten times over for the cost of throw-ing the premiere party.

After twenty-five years in the business, many of the people on her professional A-list are now on her personal one. Nowadays, Siegal, a self-described "impatient perfectionist worka-holic" who has "mellowed" in recent years, is as much a part of the scene as the creator of one. "I totally adore being around these people," she says happily. "I think the greatest gift is having really smart friends who excite you intellectually."

Okay, Peggy, so maybe we can't be your friend, but can't we at least get invited to one of your parties?

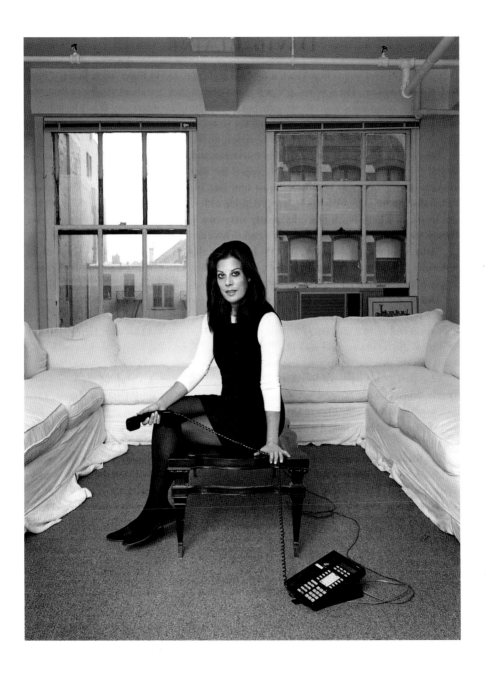

DAVID BLAINE

Though his fabulous stunts now reach a national audience, David Blaine is, at heart, a New York street magician. His acts are as much about grit as they are about sleight of hand; his favorite stage is not some Vegas showroom, but the streets of his native city. While his televisibility has brought him attention from around the globe, Blaine is most at home with a deck of cards in his hands, wowing a few kids on the street, up close and personal.

But card tricks don't translate well on television, and Blaine, who also possesses a supernatural commercial instinct, has recently upped the ante. A couple of outrageous televised stunts performed in New York have thrust him into magic megastardom. One had Blaine buried alive on the Upper West Side, trapped inside a Plexiglas case for five days. The other had him frozen in a huge block of ice for nearly sixty-two hours at ABC's Times Square studio. Though the experience was terrifying, it seems to have accomplished what Blaine wanted it to.

"After I got out, I ask myself, Why do I do these things?" says the cool-as-a-block-of-ice performer. "I want to make lasting images, like in art, but with magic. I want to make images people remember. I'm gonna keep doing it, because when I do, that's when I feel most alive."

That is about as personal as Blaine will get. He takes the magician's cloak and code of secrecy very seriously. He alters his life story nearly each time he tells it—"hearing the same story again and again is so boring," he says. Blaine, in the tradition of his idol, Harry Houdini, has had multiple aliases. And also like Houdini, the mystery that surrounds him makes his stunts that much more captivating and mystifying.

One part of his personal life that has been mercilessly explored is his friends and girlfriends. When he's not trapped in a small space, Blaine has been known to live in the city's fast lane, hanging out with the likes of DiCaprio and De Niro. He is also famous for his magic with the ladies—he has been linked with, among others, the singer Fiona Apple and the model Josie Maran.

But Blaine's most consistent love affair is with his audience and his art. For Blaine, magic is his life's passion. While you still might catch him asking some passersby on the street to pick-a-card-any-card, Blaine's still aiming high. The next stunt on his calendar is a jump off the Brooklyn Bridge. "People think I'm crazy, but this is my way of challenging every human fear," he explains. "This is how I feel good."

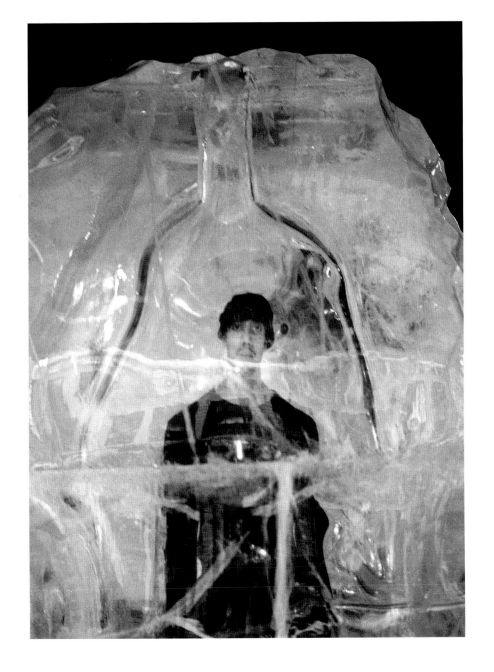

COMDEN AND GREEN

"New York, New York, it's a helluva town, The Bronx is up and the Battery's Down . . ." By now, most of you are probably singing along. For the Broadway non-cognoscenti, this infectious, snappy jingle comes from the 1944 musical *On the Town*. Like most classic show tunes, it's timeless—just like its authors, Betty Comden and Adolph Green. Comden and Green is the longest running partnership in theater history, creating some of our best-known and best-loved stage and screen musicals.

The origin of this renowned pair goes back over six decades. The year was 1939, and both of these born-and-raised New Yorkers were your basic struggling-actors-looking-for-work. Making the audition rounds, Comden and Green happened upon a nightclub gig where, along with the late actress Judy Holliday and two others, they began to write their own satirical comic material under the title *The Revuers*. "We wrote our own material because we couldn't afford anyone else's," laughs Green.

The Revuers played for several years to mixed reviews, but fortunately, a big fan was their old friend Leonard Bernstein. Bernstein suggested that Comden and Green write the book and lyrics to a show that he and Jerome Robbins had been working on. From that, *On the Town* was born, and Comden and Green, along with their pals Lenny and Jerry, had their first of many Tony Award–winning Broadway blockbusters. "And that's our showbiz story!" exclaims Comden.

While most everyone just assumes that Comden and Green are married, their sixty-year partnership has been purely platonic. "Betty was very happily married to Steven Kyle, a wonderful guy," says Green. "And he is married to Phyllis Newman, a singer, actress, and writer," says Comden in turn. "It was a good thing we never thought about getting married. It was very smart of us. We never had any of that kind of relationship. It's always work, work, work, work, work."

How does this duo do what they do? "We sit in a room and stare at each other," explains Comden, whose apartment serves as their office. "That's pretty much the way it goes. We meet almost every day. Sometimes, by the end of the day, there'll be something on the paper—very often not, but we just keep meeting. That's it!"

The tried-and-true formula has produced such stage gems as *Wonderful Town*, *Bells Are Ringing*, *On the Twentieth Century*, and *The Will Rogers Follies*; distinguished musical screenplays include *The Band Wagon*, *It's Always Fair Weather*, and—most notably—*Singin' in the Rain*. That's right. The story and screenplay from the celebrated Gene Kelly classic, consistently voted one of the ten best films of all time, danced from the pens of Comden and Green.

Spend time with these living legends and you'll learn a lesson in longevity, hard work, and, most of all, friendship. Well into their eighties, this awesome twosome is still going strong, overseeing revivals of their past hits and creating new material every day. "It just works," says Comden of their uncanny chemistry. "At this point, why should we change?"

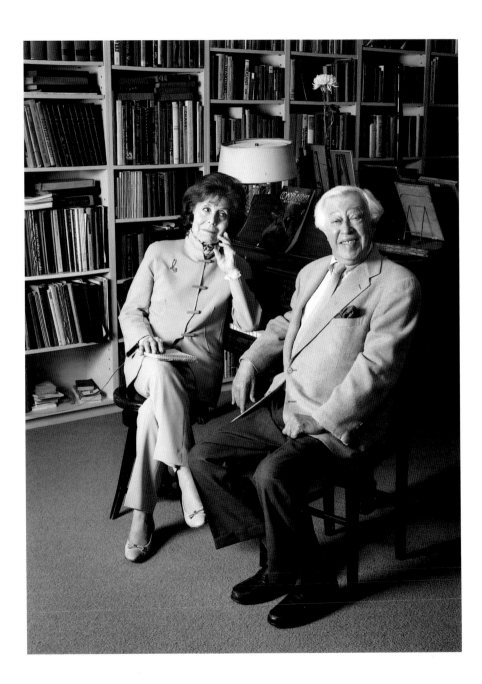

MOE GREENGRASS

At Barney Greengrass, the only thing that hasn't been around forever is the fish. Since 1908, when the Sturgeon King first started preparing his trademark lox, eggs, and onions dish at its original location in Harlem, New Yorkers have been scrambling to get a seat at the legendary Upper West Side institution. Maybe it's the Nova or the whitefish. Maybe it's the chopped liver, the babka, or the borscht. Whatever, the restaurant has a history of legendary patrons, including FDR, Groucho Marx, George Burns, and Jerry Seinfeld.

The Greengrass skill of slicing lox has been passed down side by side with the family's talent for tossing schmaltz. These days, Moe, son of the original Barney, mans the cash register, while his son Gary minds the rest of the shop. As son says of father, "This way at least if he steals, he keeps it in the family." It's an arrangement they both seem to enjoy. Moe does magic tricks with a deck of cards, while Gary attends to the corporate side of their sturgeon empire, Barney Greengrass, Inc.

Perched in his usual spot behind the cash register, Moe is as fixed in time as the decor. The register itself is from the 1940s, and the wallpaper is at least as old. The fish—the real stars of the show—sit in a white porcelain enamel display case that, Gary points out, "you really can't duplicate anymore." It's not laziness that keeps things the same, just an appreciation for the things that will never go out of style. "People feel a bond here," Gary says. "You get people who come in and say, 'My parents used to bring me here when I was a kid.' "

He could very well be talking about himself. For the Greengrasses, family is as important as fish. There is a Barney around today (Moe's other son), but he's a stockbroker and lives over on the East Side. Moe, who lives around the corner from the restaurant, seems to forgive him for it. "Barney invests my money for me," Moe explains.

With an ever-expanding brand, they can surely afford more than just a few shares of stock. Several years ago, the Greengrasses went Hollywood, teaming up with another famous Barney's family, the Pressmans, to open a restaurant in the Barneys clothing store in Beverly Hills. "Out there it's fancy-schmancy," Gary says, before a well-practiced pause. "Here we're just schmancy."

Moe has been working at the restaurant since 1937, when he was twenty-one years old. He arrives every day at six-thirty in the morning and stays until five or six in the evening. The commute is more of a problem than it used to be—forty-two years ago he moved from above the restaurant to around the corner from it—but the routine is pretty much the same. As Moe explains, "I eat a lot of fish. That's the story of my life."

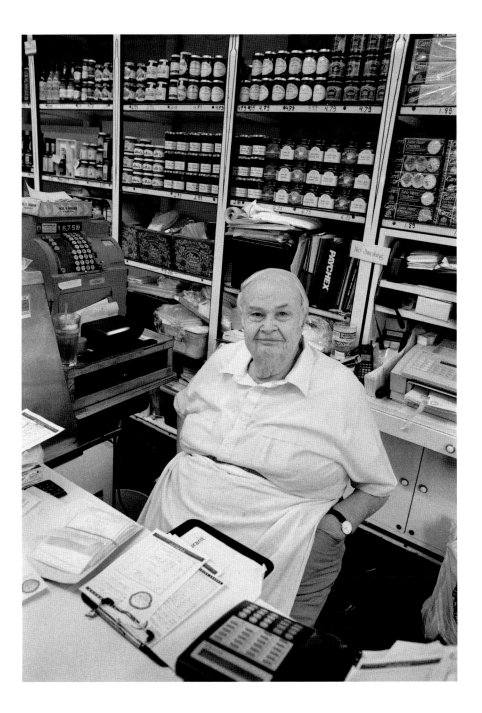

MASON REESE

In a city of about 8 million people, it's surprising how often you'll walk by a familiar face, someone you know you know but can't quite place. If you're over the age of thirty and pass by Mason Reese, a five-foot redheaded man with a cherub face and a Prince Valiant haircut, you'll probably scratch your head and ask yourself, "Where do I know that guy from?" But if you're over thirty and somewhat of a couch potato, you'll know immediately.

Reese is the ubiquitous 1970s child star who appeared in two of the most memorable and successful commercials of that era: the Underwood Deviled Ham "It's like a borgaschmord" ad, and the Dunkin Donuts munchkin ad.

"The ham commercials were amazingly successful," explains Reese, who won a best actor award for his performance. "Though I did about seventy-five other ads, everyone seems to remember that one." The Dunkin Donuts spots were also extremely popular, but because of Reese's tag line—"Don't tell me I look like a munchkin!"—they left a bad taste in his mouth. "I suffered lots of abuse because of them," says Reese. "For years, all anyone called me was a munchkin."

Appearing on *Phil Donahue*, *Johnny Carson*, and regularly on *The Mike Douglas Show* ("thirty-two times"), Reese lived the sheltered life of a child star. As for his earnings, says Reese, "I made very good money, but it was seventies money. To put it in perspective, in Gary Coleman's last year of *Different Strokes* he made more than I did in my entire career. And Macaulay Culkin made more money in one movie than Gary did in his entire career. Did I do well? Hell yeah. But let's put it in perspective."

At the age of eighteen, Reese, now thirty-six, stopped acting. "I just partied like a madman, living off all the money that I made," he recalls. "I had worked throughout my childhood, so when I stopped it was like someone let me out of a cage. From 1982 through 1990, I slept all day and went out all night, lived my life in nightclubs, and basically became a very large box of testosterone."

In 1990, a nasty motorcycle accident left Reese in a wheelchair for the better part of two years. After that, he slowed down considerably, until he opened up Now Bar in the West Village. The bar has become a well-known watering hole for "transvestites, transsexuals, and cross-dressers." (But Reese won't be "converted," remaining "painfully heterosexual.") Owning the bar allows him to work a little and still live the good life. "I put in about ten hours of work a week, and besides that I don't do a damn thing—except for the occasional appearance on Howard Stern," he explains.

"My goal in life is to be happy, which at times eludes me," he laments. "I'm still not sure what I want." But one thing that keeps Reese going is having fans still recognize him daily. "That pat-on-the-back feeling never gets old. When I realize that I did a good enough job that people still recognize me, that's a great feeling. Sometimes that can carry me and make me feel good about what I've accomplished in life. Most people will never have that feeling."

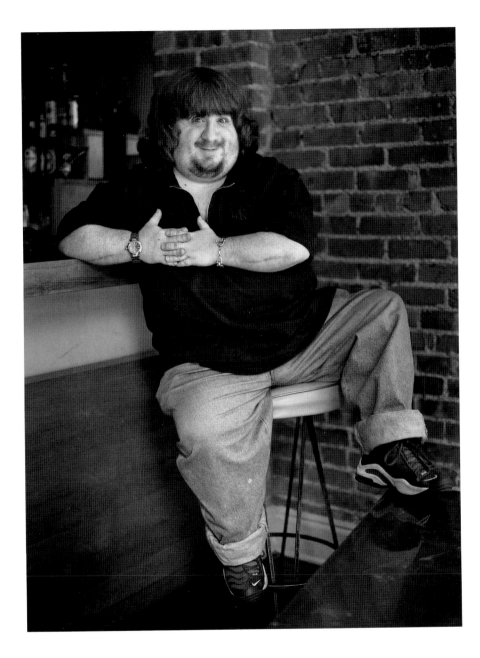

THE CHESS KING

Almost every morning at the crack of dawn, Alfie Castellano enters New York's Washington Square Park, ties his dog Jay to a lamppost, and cleans up the park with a couple of his pals. This is all in preparation for the day's chess competitions. In the southwest corner of this picturesque park—most well known for its stunning arch—sit a dozen concrete chess tables. Alfie and his "check" mates have long dominated the Washington Square Park chess scene.

This is a world unto itself. Alfie likens it to an insane asylum. "There is not a sane person who hangs out here," he insists. "We are all oversensitive, stressed out, and incredibly focused on our chess. Chess people are as a whole the most belligerent people there are. And they have no commonsense."

When Alfie arrives each morning, he says that the park resembles Calcutta, with people sleeping on the benches and feces and urine littering the bushes. After straightening up, Alfie assumes his day-long position at his very own table. "I'm the only one," Alfie proudly exclaims of his exclusive space. If Alfie's late, a friend will save his table. Others come early to claim their spots. Often, homeless people will commandeer a table and "sell" their space. Once Alfie's regulars have taken over, they'll often pay each other to hold tables while they take a break. "We want our own crowd here," he explains. "The only outsiders we like are the ones we can make money from." And make money they do. Although the tables are technically public property, the games are not free. One must either gamble on one's abilities or else pay the person occupying the table for a game. "Everyone here is either a gambler or a hustler," says Alfie.

A native Brooklynite, Alfie claims to have been a hustler since he was five years old. When a series of accidents forced him out of the construction business, he took up chess in the park. He's never left. Alfie and his pals are a makeshift family connected by their love of a park and a game. Chess, for them, is a way of life.

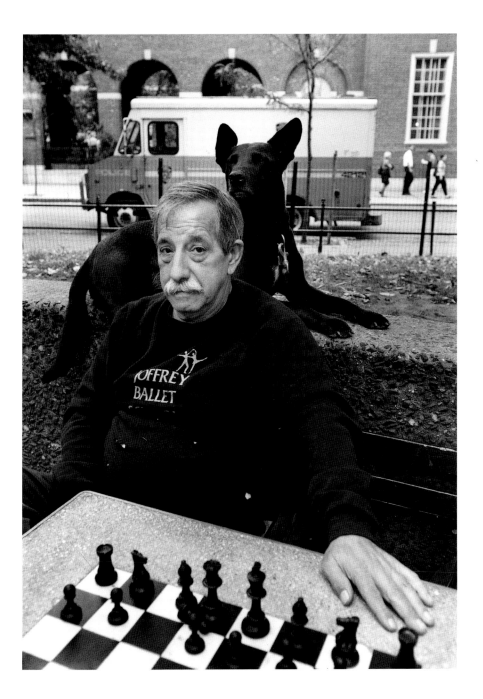

JENNIFER MILLER

In this massive melting pot of humanity, New Yorkers hardly blink as they walk by all the eccentrics populating our city's streets. But strolling past a bearded lady juggling machetes might stop even the most jaded of us dead in our tracks. Meet Jennifer Miller, the creative force behind *Circus Amok*, an extravaganza that goes up in city parks throughout the summer months. Part performance art, part theater, part social protest, and part freak show, Miller's circus is very much a microcosm of the city in which it is performed.

Miller's mission for her circus is simple and powerful—to provide the people of New York City with "free public art addressing contemporary issues of social justice." Performing seventeen acts in just under an hour, they do just that. "We focus on local city issues," says the ringmaster. And any issue is good fodder, so long as it's universal enough to bring people together. Some of their recurring political targets include police brutality, health care, the "malling" of Manhattan, and of course, New York's favorite ringmaster, Mayor Giuliani.

But while Miller always seeks to advance her political agenda, her commentary is always repackaged as family-fun entertainment. With a company that includes glass- and fire-eaters, machete jugglers, tightrope walkers, or straitjacket escapers, *Circus Amok* lives up to its name. "I learned my skills through the circus world," explains the multitalented Miller, whose first job out of high school was working as a circus clown. Miller's most impressive act is to manage a balancing act between circus and politics. "We don't have a target audience," says Miller, who performs with her troupe in diverse neighborhoods across all five boroughs; as long as the show generates "a conversation that stretches across community lines."

Of course, some people have trouble getting past her beard. "My beard started coming in when I was about twenty-two," she confides. "It started as a little wispy thing that a young feminist could wear, but then it came in more and more." For seven years, Miller worked at the sideshows in Coney Island, where the work was "grueling" but the audiences "diverse." Now, she uses her beard to further the goals of the circus. "I'm a political activist. Having my beard keeps gender questioning active," she declares.

But it's more than just her beard that keeps Jennifer Miller active. The circus season, after all, is only a summer one. So during the winter, Miller raises money for her free circus, teaches at colleges, and performs her own creatively named one-woman show, *Morphadyke Madness*. Like her circus, Miller's show "deals with things that are important in my life—gender stuff, beard stuff; it also deals with questions of otherness and the history of the display of people." It's a lot to juggle, but Miller's a performance artist who rarely drops the ball.

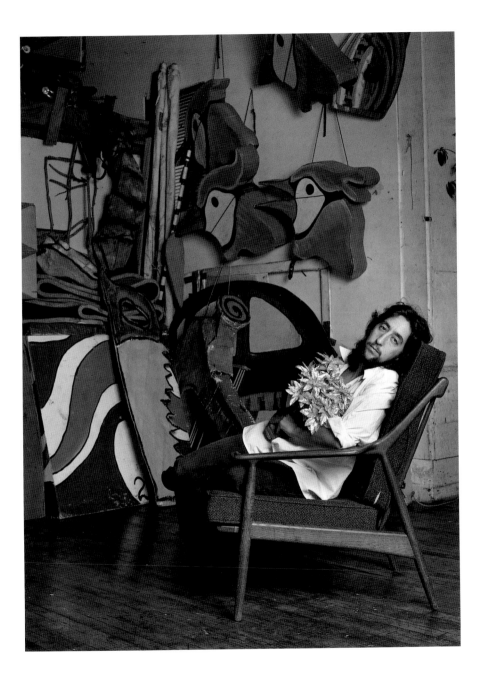

THE BUS COMIC

Taking the bus in New York City may be a lot of things, but nobody ever said it was like being in a comedy club. Then again, most people haven't been on Tony Palombella's bus. This MTA bus driver has been doing his comedy and trivia routine on various routes for over ten years. Riders board Palombella's bus in the standard catatonic state, but after listening to Tony's rap, they leave laughing and refreshed. "Some people think it's so entertaining," boasts the busman, "that they miss their stop."

Palombella is just trying to make life a little more pleasant for everybody. But he's also selling the city. "I like to change people's minds about New York," says this Bronx resident. But the initial impetus for starting the shtick was less selfless. Afraid that he was "going to turn into a robot," Palombella began researching the city, finding trivia, coming up with jokes, and perfecting his routine soon after he started driving the routes. The results have been a drive-away success. "When everything clicks, I give a good performance, they pat me on the back, it's like a natural high," he says. "It's better than liquor; sometimes it's even better than sex."

No surprise, then, that Palombella loves his job. "I get to cruise the city and get paid for it. I get to see the sights, meet people, and I get to socialize, and my boss isn't breathing down my neck." The MTA couldn't ask for better advertising. They couldn't ask for better service, either. Palombella hasn't been in a chargeable accident for over seven years. But more telling are the seventy-five letters of commendation he's gotten from various satisfied riders. Palombella gets so much fan mail, in fact, that other drivers get a little jealous. But Tony is irrepressible. "I'm a people person, I love to meet people!" he exudes. What better way than to drive around town?

Sure there are some who don't like the bus banter as much as most people. The Upper East Side is a tough crowd. So are people with the Monday Blues. Tony even gets hecklers once in a while, but in those cases the passengers always defend him. And why not. It's not every day a bus driver breaks the routine with a routine of his own. And his material's good, too. After all, not many people know who New York's first transvestite mayor was (Lord Cornberry). Or when the wall of Wall Street was torn down (1664). Or where to find a dog with no legs (where you left him).

Drivers are required to change routes every three months, so it's tough to track down this unique New York act. But if a bus drives by and all the passengers are smiling, it's a good bet that Tony Palombella's driving. And if so, a buck fifty buys the best show on wheels in town.

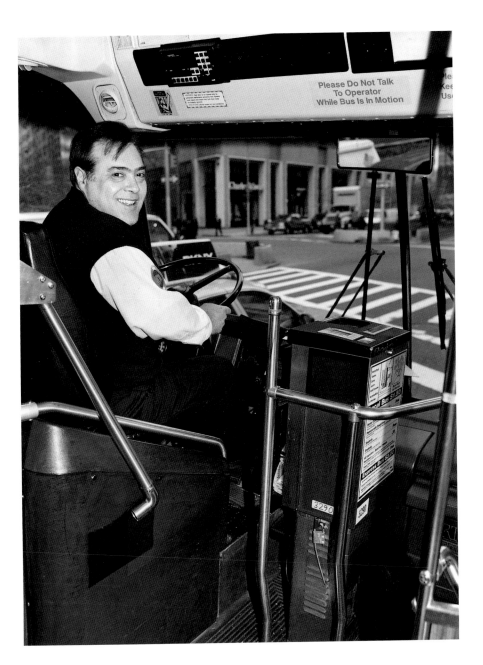

BOBBY SHORT

The crowd looks spiffy, drinking martinis and listening to the soulful crooning of a cabaret singer at the landmark Carlyle Hotel. His husky, jazzy voice mixes fluidly with the heavy smoke in the beautiful, dark-wood-paneled bar. It's a classic New York scene, an anachronism from a more elegant, simpler time. In today's fast-paced, unpolished world, it's shocking that it even exists at all. Bobby Short has been serving up his delicious renderings of American standards and Broadway classics to Carlyle crowds for over three decades. What started as a two-week replacement gig has become an American institution.

Bobby Short oozes both midwestern charm and cosmopolitan flair. Born in Danville, Illinois, in 1924, Short was a prodigious child performer dubbed the "miniature king of swing," touring in vaudevilles around the country. By the 1950s, he had made his way to New York and attracted loyal following in various Manhattan nightclubs before settling into his enduring seat behind the grand piano at the Carlyle.

Short performs at the forever-chic hotel twenty to twenty-four weeks out of the year, five nights a week, putting on one-hour shows at 9:00 p.m. and again at 11:00. Like most people who are passionate about what they do, Short lives to work. "It's a very jealous mistress," he confides. "When I'm working, it's my first priority and everything else is built around that. No longer being a lad of twenty, I try to eat properly and sleep properly, with everything being focused around doing my job."

His performances, as one critic described them, "combine superb musicianship with an impeccable taste in songs." The impeccable taste also extends to Short's wardrobe. His stylish dress and manner not only embodies the image of what a classy cabaret singer should look like, it defines it. "I like to think that in some way I'm a reflection of New York," observes Short. "Most of what I've learned about my business I've acquired by working in this city."

And to paraphrase the song, since he's made it here, he's made it everywhere. A nationally acclaimed performer, Short has done gigs on Broadway, stints with the Boston Pops, and numerous performances at the White House. Along the way, he's picked up three Grammy nominations for his timeless brand of music. "It's evergreen music," he says of his shows. "Playing the piano and singing is portable. You'll find piano players and singers everywhere, from the lowliest barroom to a grand room like the Carlyle."

So long as Bobby Short mesmerizes audiences with his harmonious tunes, a more refined world with sophisticated taste will continue to exist at 76th and Madison. As an American era fades from our collective memory, Short is the torchbearer of the torch song, a popular singer of the popular music of our nation's past. As Cole Porter would say, he's the top.

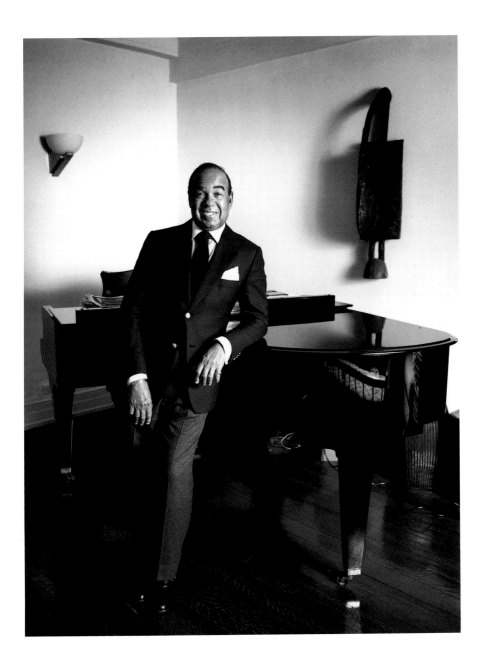

THE REAL KRAMER

B.S., or Before Seinfeld, Kenny Kramer lived the unremarkable life of a Manhattan bachelor. S.S., Since Seinfeld, Kramer—the real-life inspiration for Jerry's unemployed, scheming neighbor Cosmo Kramer—has become one of the city's most popular tourist attractions. Who would have thought that this lanky, affable native New Yorker would rival the likes of Lady Liberty and the Twin Towers as one of the city's most visited spectacles?

Certainly not Kramer who, Before Seinfeld, never held a steady job. But Since Seinfeld, Kramer has taken his association with the 1990s' most beloved sitcom and turned it into not just a job, but a booming business. For the past five years, Kramer has spent his days running Kramer's Reality Tour, a bus trip through the city that visits the sitcom's sacred sights. Tour stops include Tom's Diner, the Morningside Heights eatery that served as the facade for Jerry and his gang's neighborhood diner, and the International Soup Kitchen, the spot upon which the famous "Soup Nazi" episode is based. Kramer narrates throughout, interspersing real-life tales with sitcom plotlines. The tour regularly sells out and, ironically, has outlasted the show. Thank goodness for syndication!

This all came about because, during much of the 1980s, Kramer lived across the hall from Larry David, Seinfeld's co-creator. They resided at Manhattan Plaza, a housing complex for performing artists on 43rd Street between Ninth and Tenth Avenues, and tried to make their way as stand-up comics. David, who based the character George Costanza on himself, used Kenny as the model for the wacky, eccentric Cosmo Kramer. Kramer's life back then, like that of his fictional counterpart, was a constant adventure. While attempting to make his way as a standup, Kramer held innumerable jobs, including designing electronic jewelry, managing a reggae band, and voicing adult porn CD-ROMs. Always driven by a desire to be famous, Kramer's finally got his wish. "I'm the luckiest guy in the world," he says. "Only in America could something like this happen." No Kenny, only in New York!

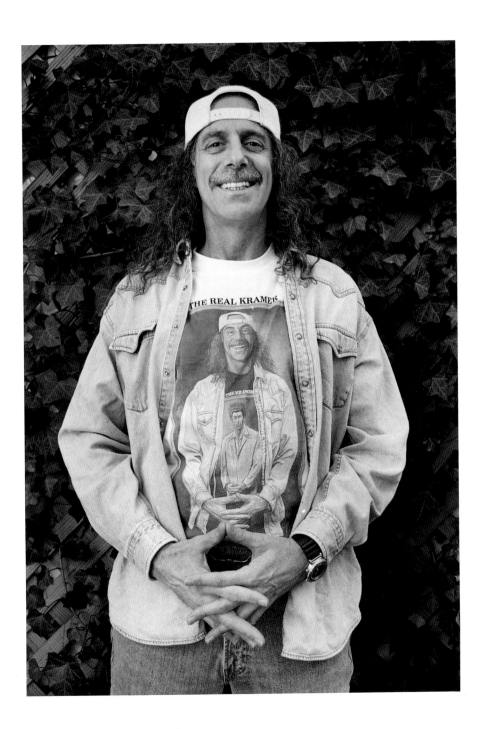

THE LITTLE OLD AGITATOR

New York is a city full of small treasures: blossoming neighborhoods, vest pocket parks, and—protector of both—a little old lady named Evelyn Strouse. Holding court in Union Square the way a gargoyle wards off evil spirits, Evelyn is one of the most powerful, and surely one of the smallest, voices in the rough-and-tumble world of neighborhood activism.

It's not that she looks particularly scary—at four feet eight, eighty-something years old, and, thanks to osteoporosis, perpetually shrinking into a park bench—but her bite is far worse than her bark. It goes something like this: if you have business to do in her neighborhood, no matter how rich or big you are, you had better be prepared to deal with Evelyn.

Isaac Tigrett, an entrepreneur, learned this the hard way when he tried to open a House of Blues nightclub on Union Square. When Evelyn, as its chairperson, put the full weight of the Union Square Community Coalition behind her and stopped the plan, Mr. Tigrett nicknamed her "the Agitator." The sobriquet suits her well. Evelyn's power is sorcererlike, coming as it does in such a small package. She's like the wizard of 14th Street.

It has been a part of who she is since the day she was born on a kitchen table in Harlem. After raising her kids in Westchester and kicking some dust in local politics there, Evelyn moved to Israel in 1974, fed up with U.S. involvement in Vietnam. When she returned to New York in 1981 and settled on 16th Street, the neighborhood, as she puts it, "was in pretty bad shape. There was selling, buying, and falling down dead." And changing it, she believed, was her responsibility. "I really do think you should brighten your corner of the world," she says.

Within a few years she had become chairperson of the Union Square Community Coalition, and fighting to keep the neighborhood safe and livable had become a full-time job. Evelyn helped get the drug dealers out and the park cleaned up; she beat City Hall in a zoning fight and more than one developer with a bad idea—all to preserve the essential neighborhood quality of Union Square.

Lest her appearance suggest otherwise, her success has not gone unnoticed. Danny Meyer, the well-known restaurateur and proprietor of Union Square Cafe, once said that "Evelyn is the heart, soul and conscience of the Square." In his column in the *New York Times*, Robert Lipsyte wrote of Evelyn that "every neighborhood has, or needs, that one old lady—often young, sometimes a man—who will help make government fulfill its mandate to the people." They are the sort of accolades that her friends—and especially in Union Square she has many of them—can't resist.

And, true to form, it's not a responsibility she shies away from. "I'm not afraid of anybody," she says. "I'll fight like a tiger." Seeing her storm through the park with her head up and her back hunched, you'd have to be a fool to disagree.

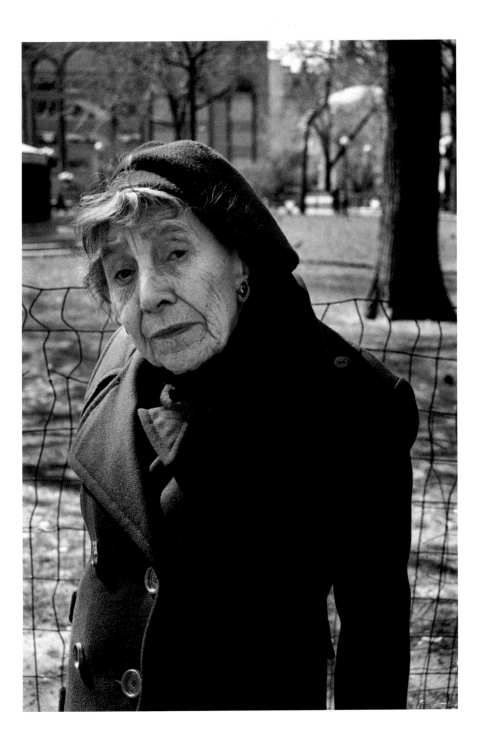

DANCIN' LARRY

Forty-one nights a year, the Rangers take Manhattan. And on each of those forty nights, Larry Goodman journeys across the Hudson River from his home in Clifton, New Jersey, to Madison Square Garden, the world's most famous arena. When this mild-mannered, bald-headed man enters his beloved Garden (New Yorkers simply call it "the Garden") and catches his first glimpse of the ice, Goodman transforms into the hyperkinetic Dancin' Larry.

His ritual has become as much a part of a Rangers game as a good, hard check against the boards. Several times a night, disco blares from the arena's rafters and all eyes focus on section 407, in the highest rows of the stadium. There's Dancin' Larry, doing his thing. Goodman's dancing falls somewhere between a skilled hip-swiveling gyration and an epileptic fit. While not quite Fred Astaire, his moves have made him one of New York's most famous athletic supporters.

Dancin' Larry is a direct descendant of Dancin' George (and both are indebted to The Chief, the first of the Rangers' fanatics). By all accounts, George cut quite the rug (or the aisle). George and Larry were section mates, and one game, with George on an unexplained sabbatical, Larry's pals urged him to pinch-hit. "I stunk at first," admits Goodman. But one fateful night, the Garden displayed Larry and his moves on the big-screen GardenVision high above the ice. The crowd went mad. The rest, as they say, is history. Dancin' Larry was born.

Goodman, who in his free time hangs out at sports bars and listens to Howard Stern ("my hero," proclaims Larry), pays for his seats like everyone else, though the Rangers give him a new jersey every year. He's only been dancing since 1996, but he's had season tickets since 1988. He's there every night, spazzing out a few times a game, bringing a smile to everyone's face. (Even the Great Gretzky was caught grinning up at Goodman from the Garden ice.) And yes, Goodman's done weddings and bar mitzvahs.

"I'm one of those people who goes from job to job," says Goodman, who's worked for an elevator company, a record store, and a magazine distributor, among other employers. "But the Rangers gig I'll never give up—that's my livelihood!"

The Rangers went fifty-four years without a Stanley Cup, hockey's championship trophy. In 1994, they finally captured the title. "Now We Can Die In Peace," blared the tabloid headlines. "The best moment of my life," said Dancin' Larry.

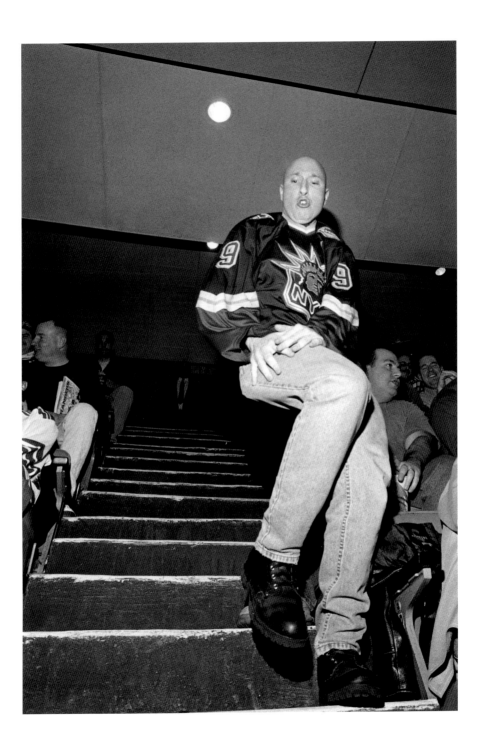

RON KUBY

To be on the very far left in one of the world's most liberal cities is quite a feat. But for Ron Kuby, it's a career. After William Kuntsler, the famed civil rights lawyer, died in 1995, Kuby took the liberal baton from his mentor and former law partner and has run with it. "The ACLU will represent you if you sit in front of the South African Embassy," says Kuby, quoting Kuntsler. "We'll represent you if you blow it up." He's not kidding. Kuby has made a career of representing the underdogs of the radical left, defending those that no one else will.

No wonder then that Kuby, a Cleveland native, set up shop in New York. This city is "the center of the counterculture and intellectual life in this country and it always has been," explains Kuby, who looks the part of a radical lawyer with his trademark ponytail. "It's the home of artists, writers, revolutionaries, dissidents, poets, and everybody who wants to make a change in some way." And when these people run up against the law (or "the Giuliani morality police," as Kuby calls them), Kuby is there to help.

As he puts it, Kuby has spent his career "forcing the government, fighting the government, and challenging the government." Almost every client he takes on fits into this game plan in one way or another. There was the First Amendment case representing the photographer who wanted to photograph nudes around the city. Or defending protesters of police brutality who were prevented from speaking their minds (Kuby himself got arrested—for the fifth time—protesting the Amadou Diallo cases). He was widely criticized for taking on the case of several of those accused in the World Trade Center bombing. And then there was Colin Ferguson, the Long Island Rail Road murderer, whom Kuby represented because he believed Ferguson was "clearly insane and incapable of representing himself." There's no real equation for who Kuby does or doesn't represent. He simply looks for people who need his help because of "the injustice that's being visited upon them."

Recently, however, Kuby has taken his advocacy beyond the courtroom. Since 1996, Kuby has been arguing his case every weekday with Curtis Sliwa, the conservative founder of the Guardian Angels, on WABC Radio's *The Curtis and Kuby Show*. And suddenly a lot more people are hearing Kuby's side of things. He says that since the radio show, "people don't hate me the way they used to. It's weird. I think I'm starting to turn some listeners around." He certainly has an audience; the show is one of the most listened to talk radio programs in the city.

Still, Kuby's number one priority is representing the unrepresented. He's a civil liberties superhero: whenever someone's rights are infringed on, Kuby swoops in to the rescue. But his sights are set much higher than any individual's plight. Kuby's ultimate goal is "to overthrow the government of the United States and build a society based on true equality and true justice," he pledges. It's a tough case, but Kuby's on it. The jury's still out.

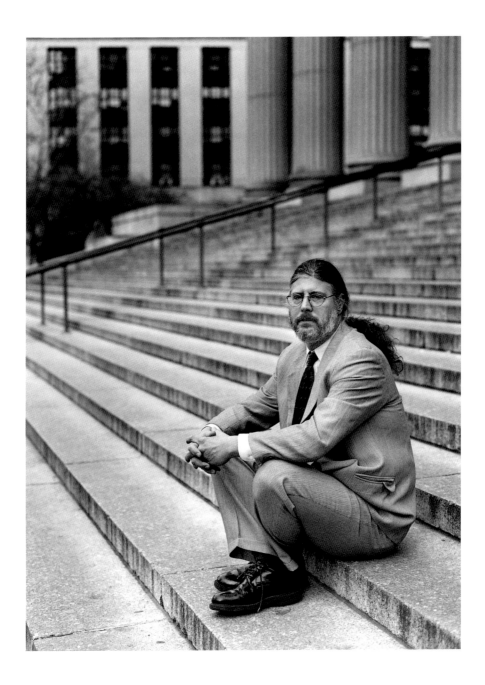

BRINI MAXWELL

Many a New Yorker has been there before. You're channel-surfing on a Friday night, recovering from a long week at the office, and you can't find anything on the tube. Just as you reach those no-man's-land channels in the mid-30s and you're about to give up all hope, you find yourself entranced by an infectious jingle. The show looks and feels very seventies, kind of like *Mary Tyler Moore* meets *Laverne & Shirley*. But it's neither. It's *The Brini Maxwell Show!*

Brini Maxwell, the drag queen persona of Chelsea resident Ben Sander, has been entertaining and educating New Yorkers of all stripes for the past three years. Imagine a pitch to a network programming executive: how about a takeoff on *The Martha Stewart Show*, except instead of Martha and her well-appointed Connecticut surroundings, we'll have a drag queen dishing out household tips from her tiny, seventies-style Chelsea apartment? Well, that's *The Brini Maxwell Show*.

Ben Sander had been doing drag since his high school days in Cleveland. After stints at the Kansas City Art Institute and New York's Fashion Institute of Technology, Sander settled into his Chelsea neighborhood. He was leading the quiet life of a drag queen until one day a set of mixing bowls turned his world around.

Sander explains: "I had been redecorating my apartment to look like a sixties movie set. So I went to the Salvation Army and found a set of Pyrex mixing bowls in mint condition with little figures of farmers on them. They were wonderful but I realized that they were for food preparation and no one would ever see them. So I decided to do a TV show so that everyone could see them."

Brini Maxwell ("Brini," short for Sabrina, comes from a Stephanie Powers character in the 1970s TV movie classic *Deceptions*; "Maxwell" pays homage to Streisand's *What's Up Doc?*) is not your mother's home economics teacher. Dispensing advice like "how to throw your child a post-prom brunch" or doling out useful tidbits like "your meat loaf will be lighter in texture if you add a little mashed potato to the mix," Brini has developed a following that extends beyond a gay audience. Indeed, her biggest fans are her parents, who wholeheartedly support her efforts both financially and emotionally. (Her mother, actress Mary Jane Wells, is actually the show's camerawoman; her father is a drama professor on Long Island.)

"Brini is so different from me," says Sander, who as a boy claims to looks better with a beard. "She's so perfect and really defines social acceptance." Whether she's throwing Tupperware parties (you can hire her for your next one) or advising her viewers on a not-so-messy way to cook bacon, Brini is our very own damsel of domesticity. Martha who?

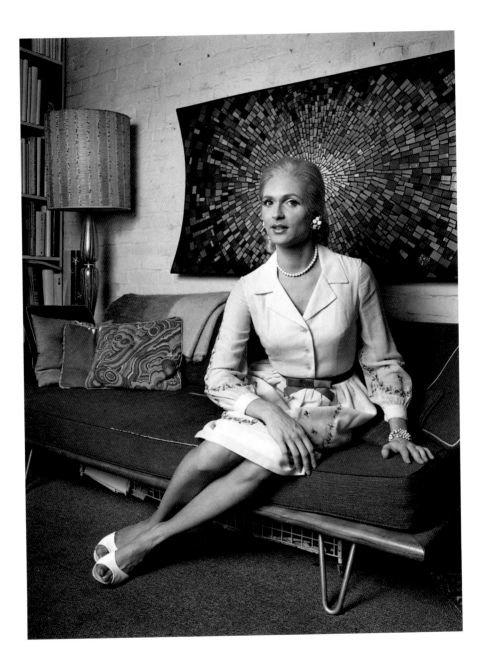

CAROL TAYLOR

Carol Taylor is New York's number one foot soldier in the fight for black justice. If there's a protest, a rally, or a need for civil disobedience, you can be sure Taylor will be standing front and center, holding a sign and howling for an end to "colorism." ("Racism," she explains, implies two races, and Taylor believes that there is only one race.)

Growing up in a white neighborhood in upstate New York, Taylor recalls being called "nigger" or "blackie"—epithets made more confusing by the fact that her mother looked white. "I've had it from both sides," Taylor says. "I think that's probably what ignited the fire that burns inside of me." Her determination to transcend the color barrier revealed itself when, in 1958, she became the first black flight attendant in the United States, flying for New York carrier Mohawk Airlines. She took the job, she says, to fight discrimination, not because she found pointing out exit signs and serving tomato juice appealing. The job lasted only six months, ending when Taylor married and moved to Trinidad. After living abroad for a few years, Taylor moved back to New York in 1977, a bleak time in the city's history. She found the Big Apple rotting at its core, and racism worse than ever. She asked herself, "What can one person do?" As she's been demonstrating for the last twenty years, plenty.

Taylor is omnipresent throughout the city, showing up on street corners, subway platforms, and buses, preaching about colorism and selling copies of *The Little Black Book*, a "survival guide," written after her son was mugged and the cops treated him like the perpetrator. Taylor suggests that all black men carry the book, which lists their constitutional rights and suggests appropriate behavior in the event of being stopped by police. It includes everything from Rule #1: "If you are hailed by the police: do not run," to Rule #16: "Do not wear leather." In the back of the book, Taylor has listed the dozens of black men who have been killed by the police. It's a poignant and controversial reminder of what she's been fighting for all these years.

In addition, Taylor founded the Institute for Inter-"racial" Harmony, with the motto, "Prejudice is learned, it can be unlearned." To demonstrate the extent of color-based discrimination and prejudice, one of the institute's first actions was to create the RQ, or Racial Quotient, test. The test was designed by a psychologist to determine an individual's relative degree of discrimination. Acknowledging that almost everybody who takes the RQ fails, Taylor admits that it's really just a way to jump-start a dialogue on race.

In recent years, Taylor has raised her profile by closely aligning herself with the Rev. Al Sharpton. "Several years ago, I began to see him all over the place," explains Taylor. "So I attended his rallies, listened to him, and liked what I heard." Taylor and Sharpton can often be found arm-in-arm at the same demonstrations and rallies. But where Sharpton's the lead singer, grabbing the microphone and ensuing headlines, Taylor's the drummer, more in the background but every bit as vital. For over twenty years, she's kept the beat alive, and shows no sign of slowing down.

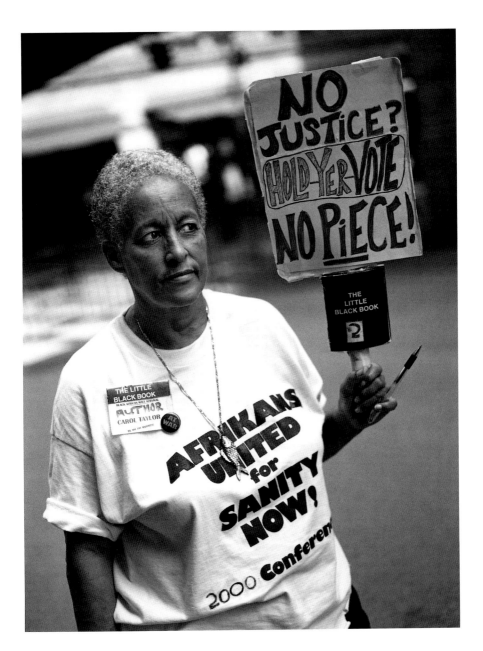

EDDIE BOROS

"One man's trash is another man's treasure," is a common cliché, but words to live by? They are for Eddie Boros. Eddie spends his days wandering the East Village, where he's lived his entire life, searching for discarded treasures. And what does he do with the spoils of his daily hunt? If you've ever been by Avenue B and Sixth Street, you would know. Smack dab in the middle of a small community garden stands Eddie's life's work—a six-story spire that is constructed entirely out of other people's trash. Reminiscent of the Eiffel Tower, the bulk of the sculpture is wood, pieces of lumber of all shapes and sizes (much of it stolen from a construction site years ago) nailed together in an irregular grid of sorts. But spread throughout the lumber are the prizes that Eddie has pulled from garbage graveyards around the neighborhood.

"I find everything," says Eddie. "And every time I find something, I say, where the hell am I going to hang it?" The answer seems to be just about anywhere. Jutting out from the tangled web of wood is a cornucopia of castoffs: a wheelchair, a French horn, an army of stuffed animals, and countless rocking horse heads. But like the suddenly super-hip neighborhood that surrounds it, the tower is constantly changing. Eddie finds something new to add to his baby almost every day.

"My sculpture is alive," claims Eddie. And while nobody expects the tower to suddenly grow legs and walk away, you get the sense talking to the sculptor that he's created a companion, a Frankenstein of revived rubbish. For Boros, the tower also serves as a place of refuge. "When I want to get away from the world, I'll climb up the sculpture and talk with it," confides the artist. "Fortunately," he laughs, "it doesn't talk back."

Some pieces of junk don't "speak" to Eddie and are not quite right for the sculpture. These items often end up in Eddie's apartment, which is something of a muddled museum. Piled from floor to ceiling are bicycles, homemade harps, exquisite music boxes, and female mannequins and other semiprecious steals. Amazingly, Eddie was born in this very same apartment in 1932, but feels no urge to move. Whenever this urban archeologist needs a change of perspective, he just shifts his bed to a different part of the apartment, and a whole new world of artifacts emerges.

Some East Village residents fear—and some yearn for—the day that the fifty feet of wood will suddenly come crumbling down. But the thirteen-year-old sculpture shows no signs of aging, and now that the structure's become an unofficial landmark and an international tourist draw, chances are it'll be around until Eddie says otherwise. And if that's the case, then this may be a piece of trash that's just too good to throw out.

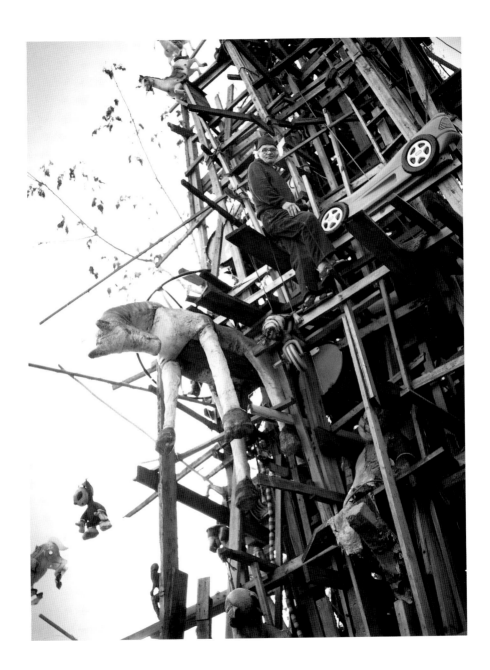

Afterword

The genesis of *New York Characters* dates back to 1997, when I studied at the International Center of Photography. Each day, I would walk from my Upper West Side apartment across Central Park to the school's Fifth Avenue location (it has since moved to midtown). It was a glorious commute: entering the park at 81st Street, I'd stroll counterclockwise around the path encircling the reservoir, with runners of all shapes and sizes streaming by.

After several months of this cross-town journey, I began to recognize some familiar faces. Walking past the reservoir's southeast gate, I would notice this old, jovial, mustachioed man parked on the bench. He was always holding court and seemed to know everyone. One day he would be talking with a homeless person; the next day he'd be chatting it up with an Upper East Side socialite.

Who was this guy? My curiosity piqued, I finally approached him and asked that he tell me his story. He was Alberto Arroyo, and his nickname, not surprisingly, was the "Mayor" of the Reservoir. Among New York's long-distance runners and Central Park lovers, Alberto was a legend.

Hearing Alberto's story made me realize that what makes New York such a vibrant and exciting place is its people. Forget the theater, the restaurants, the gorgeous skyline. New York's great mass of humanity is what gives this city its true character. Among the 8 million or so, there are those who, for one reason or another, stand out from the crowd. Some are prominent celebrities synonymous with the city; others are either neighborhood fixtures, eccentrics, or personalities famous in their own New York subculture. Selected from a broad cross section of New York's population, these "characters" define this wondrously diverse city down to its very core.

I found my characters in myriad ways: personal experience (I walked past the Urban Shepherd on my way home from the Javits Center), periodicals (I read about Radio Man in a magazine), recommendations from friends (sports fanatics told me about Dancin' Larry, Fireman Ed, and Freddy "Sez"), and tips from the characters themselves (Curtis Sliwa told me about the Brooklyn Dodgers Sym-Phony Band). Sometimes I would just show up in a particular neighborhood and ask around (which is how I discovered Eddie Boros and his magical tower). Although most of the subjects were flattered to be included, a few required a bit of prodding. In some cases, it was more like stalking. (I probably called Spike Lee's office thirty times before he finally scheduled a photo shoot and interview.)

This book is not, of course, a comprehensive list of New York characters. Constraints of time, page length, and access limited the number of subjects I could include. While readers are bound to ask, "What about him?" or "What about her?" (yes, Woody Allen dissed me—and I got into a fight with the "Soup Nazi"), my hope is that, collectively, the personalities that I have chosen reflect the unparalleled spirit of New York City.

TECHNICAL NOTE: I took all of the photographs with either a Nikon F90X or the Mamiya 645AF and used various lenses with each camera. I shot with either T-Max, Tri X, or Plus X film.